THE ENGLISH RIVIERA

PAIGNTON, BRIXHAM & TORQUAY

THROUGH TIME

Anthony Poulton-Smith

T0206551

AMBERLEY PUBLISHING

First published 2012

Amberley Publishing
The Hill, Stroud
Gloucestershire, GL5 4EP

www.amberley-books.com

Copyright © Anthony Poulton-Smith, 2012

The right of Anthony Poulton-Smith to be identified
as the Author of this work has been asserted in
accordance with the Copyrights, Designs and
Patents Act 1988.

ISBN 978 1 4456 0947 8

British Library Cataloguing in Publication Data.
A catalogue record for this book is available from
the British Library.

Typeset in 9.5pt on 12pt Celeste.
Typesetting by Amberley Publishing.
Printed in the UK.

Introduction

Three towns, each with an individuality and identity all their own, today linked under the umbrella of Torbay Council. Historically this trio is connected only by the bay of the same name. Both the sea and the topography have influenced the development of the area known and promoted as the English Riviera.

Britain's weather comes predominantly from the south- west. However the bay faces east and is protected by two natural features. Inland is the massive expanse of Dartmoor, which encourages clouds to drop their moisture before it reaches this eastern coastline. The second can be seen when facing out towards the English Channel: the dominant headland jutting out to the right. This is Berry Head. Together these features protect the area, providing the famed sub-tropical climate that has attracted visitors for more than 150 years, since Isambard Kingdom Brunel brought his railway to south Devon.

Paignton has grown from a Saxon settlement to the popular resort we know today. Long, golden sandy beaches, backed by the grassy area of Paignton Green, make for the epitome of a family holiday. Over the years, successive generations have brought their children to enjoy the place they remembered so fondly from their own childhood. However the town also extends inland, away from the beach and Promenade. A thriving shopping area exists and beyond that is the earliest surviving part of the town, centred on the parish church and Winner Street.

Little of what is now the town of Torquay existed prior to the coming of the railways, and much of the town is still recognisably Victorian in origin. Situated on the northern shores of the bay, Torquay boasts an impressive assortment of retailers, this area almost entirely pedestrianised. An exciting list of famous performers adds to the thriving nightlife, of which Torquay has been justifiably proud for many years. Torquay's most obvious feature is its large harbour, home to countless pleasure craft of every size.

Brixham was once the busiest fishing port in England. It was here that Brixham Trawler fleet was based. It numbered some 300 at its peak and was working right up to the Second World War. This traditional fishing village is traditionally held to be the quietest of the three, yet nobody seems to have told the visitors who frequent the bustling quayside and main streets, many sampling the locally caught seafood. Lining the streets overlooking the harbour are colourful buildings, little changed since the nineteenth century.

Dotted around are many villages, which contrast with their larger neighbours. The thatched roofs of Cockington; the heights of Babbacombe Downs offering glorious coastal views; and Galmpton and its association with the home of Agatha Christie, styled the 'Queen of Crime'.

No less than twenty beaches and secluded coves are to be found on these 22 miles of coastline around the bay. All these places are well-served by a long list of attractions and events. Within these pages we shall look at the changes over the last century or so, not only in terms of the places but the attractions and those who came to enjoy them. Almost 200 images, old and new, enable the reader to share the changes, and it may come as a surprise to find out what has changed and what is still very much recognisable a century later.

Acknowledgements

Rob Jennings – Page 10 top.
Galmpton & Churston Local History Group – Page 17 top, Page 94 top, Page 95 top.
Veronica Irwin – Page 19 top, Page 20 top, Page 22 top, Page 31 top, Page 34 top, Page 81 top.
Paignton Zoo – Page 36 top and inset, Page 37 top, Page 38 top, Page 39 top, Page 47 top, Page 61 top, Page 63 top, Page 64 top.
Babbacombe Model Village – Page 72 top, Page 76 top, Page 77 top.
Wikipedia Commons – Page 36 top, Page 37 top, Page 38 top, Page 39 top, Page 76 top, Page 77 top, Page 79 top, Page 80 top.
Andrew Brierley – Page 48 top, Page 54 top.
Brixham Heritage Museum – Page 65 top, Page 68 top, Page 88 top.
Benjamin S. Schwarz – Page 90 bottom.
The Library of Congress (Ref: LC-DIG-ppmsc-08054) – Page 90 top.
Martyn Hearson – Page 66 top.
H. T. Sutters of Hereford – Page 40 top, Page 41 top, Page 43 top, Page 53 top, Page 59 top, Page 73 top, Page 80 top, Page 91 top, Page 96 top.
Terence O'Brien – Page 55 top, Page 58 top.
Mike Lidgley – Page 51 top, Page 60 top, Page 74 top, Page 78 top, Page 79 top.
Peter Davies – Page 42 top, Page 46 top.
Tim Cornwell (Flickr) – Page 67 top, Page 93 top.
Greg Norden – Page 52 top.

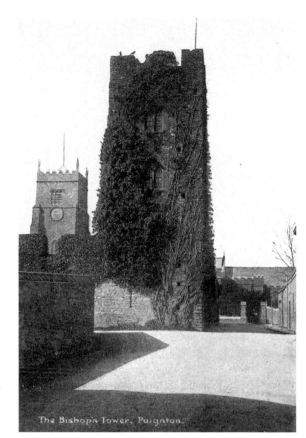

The Bishop's Tower, Paignton.

Coverdale Tower

Coverdale Tower is named after Miles Coverdale, Bishop of Exeter 1551–53. He published the first English translation of the Bible in 1536 and is reputed to have lived in the tower at some period.

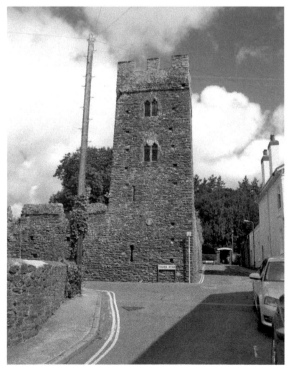

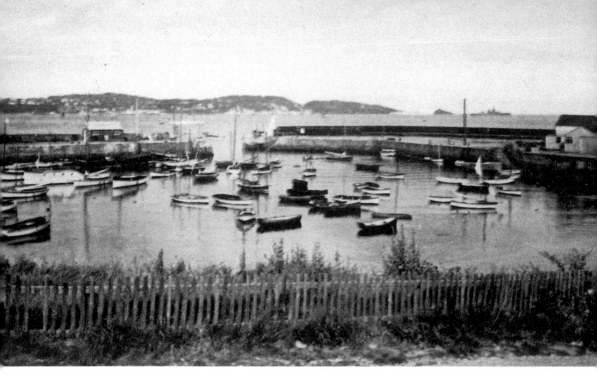

Paignton Harbour

Originally a small fishing village, the present harbour was built in 1847. It is still a working harbour, although the modern version is entirely linked to leisure pursuits. In the summer season ferries depart for Torquay and Brixham, with deep-sea fishing trips leaving on the early morning tide.

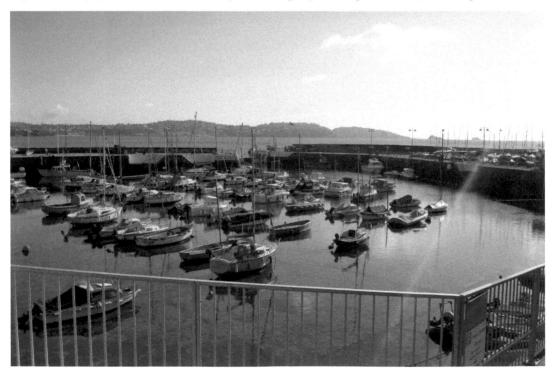

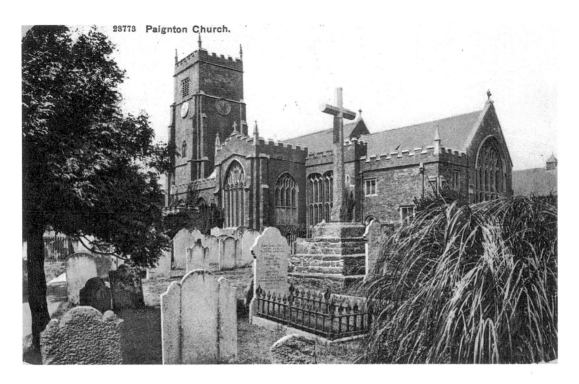

28773 Paignton Church.

Parish Church

Paignton's parish church has some remnants of the Saxon era. On entering the church the first thing to note is the Norman font. During the fifteenth century it was replaced by a modern example, with the original buried in the churchyard. Four centuries later it was found and, following a spell as an ornamental garden vase, it was returned to its rightful home in 1930.

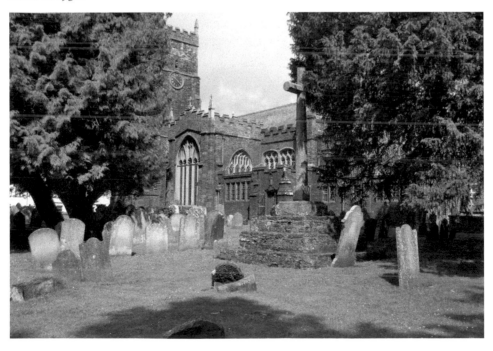

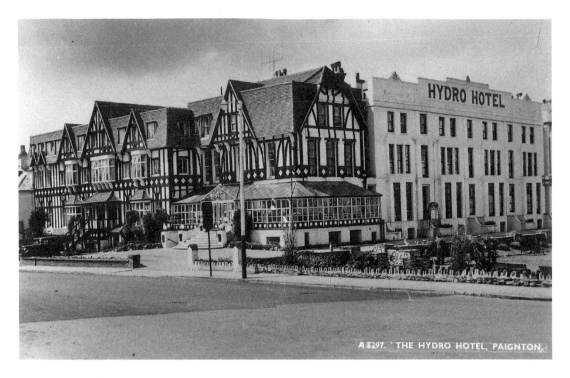

A 5297. THE HYDRO HOTEL, PAIGNTON,

Paignton Hotels
These purpose-built hotels on the corner of Esplanade Road and Sands Road have changed little over the years, though these images are separated by more than sixty years.

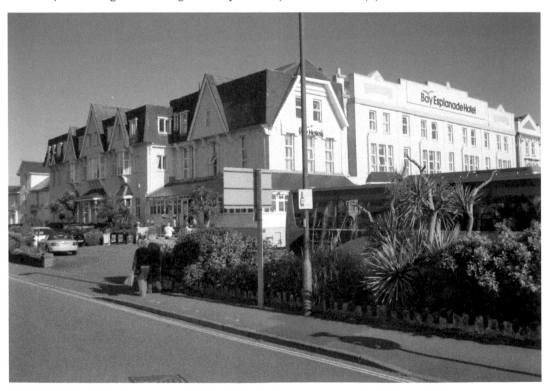

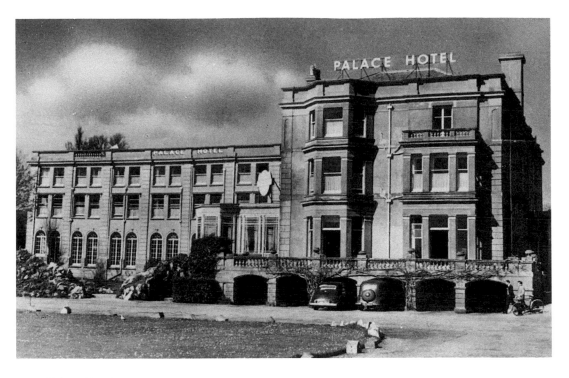

Palace Hotel

The Palace Hotel on Esplanade Road had few problems with parking in the 1940s. Note how the level of the car park has risen by several feet over the decades, as indicated by the arches over the parked vehicles in the top picture.

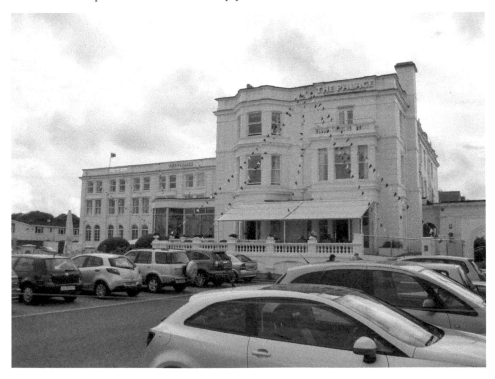

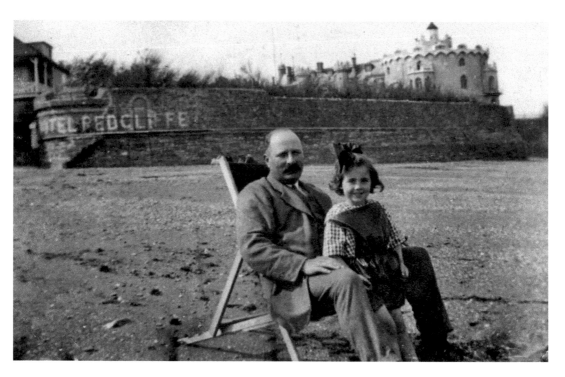

Redcliffe Hotel

As stated on the wall, the building in the background is the Redcliffe Hotel. Built as a private residence in 1856 by Colonel Robert Smith, his home was designed with a distinct Indian theme to reflect his service in the Royal Bengal Engineers. It has been a hotel since 1904.

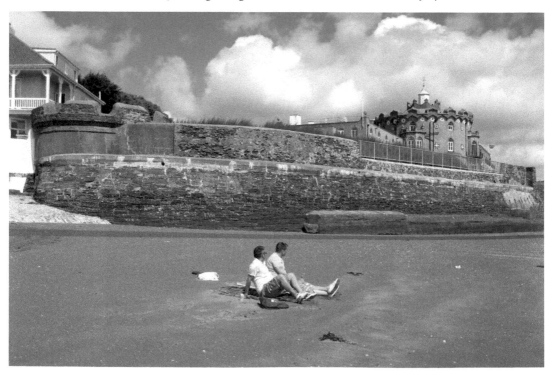

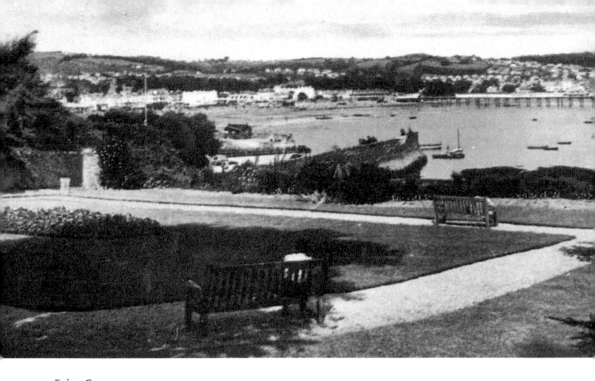

Fairy Cove
The view from the gardens on Cliff Road, Roundham Head, is of Paignton Sands. There is also a path with steps leading down to Fairy Cove, a small enclosed beach beyond the harbour encircled by the local sandstone.

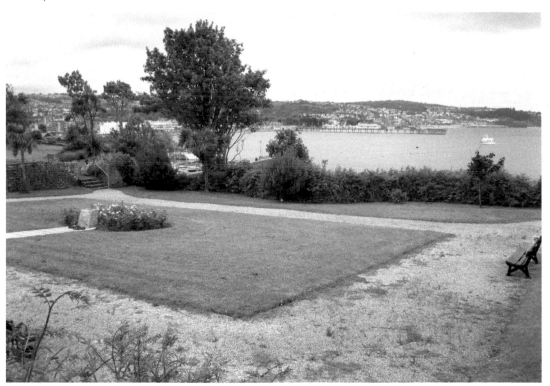

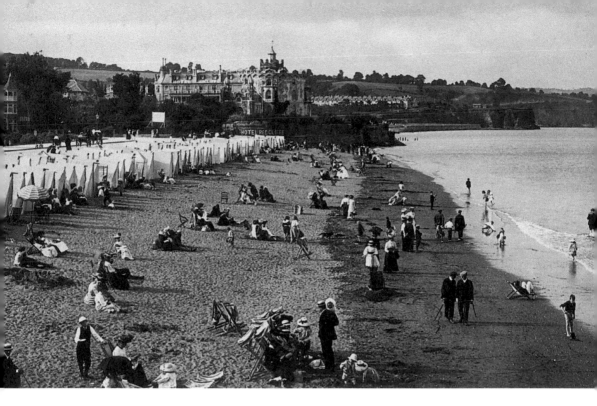

Bathing Tents and Beach Huts

Bathing tents at Paignton Sands seen shortly before 1920. These were replaced by beach huts, with demand peaking in the 1950s. Users from the Edwardian era would be astonished to learn that beach huts sold for between £15,000 and £150,000 in 2009, with one fetching an astonishing £290,000.

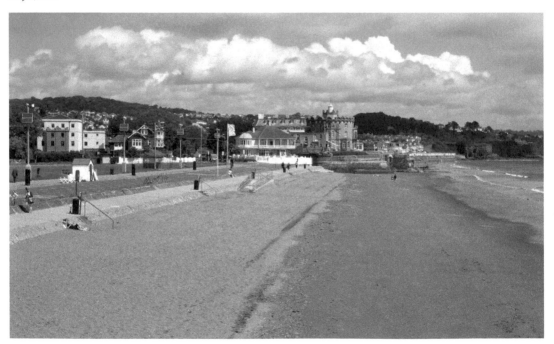

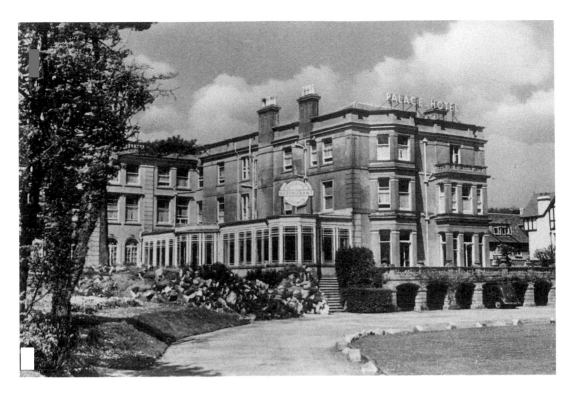

Steartfield House

The Palace Hotel was built around 1870 as the private residence of Washington Singer, son of Isaac Singer, whose name is synonymous with the sewing machine. Steartfield House, as it was then known, included stabling, which is still standing, albeit as retirement flats in Steartfield Road.

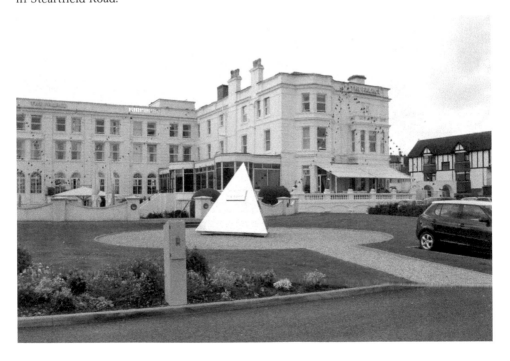

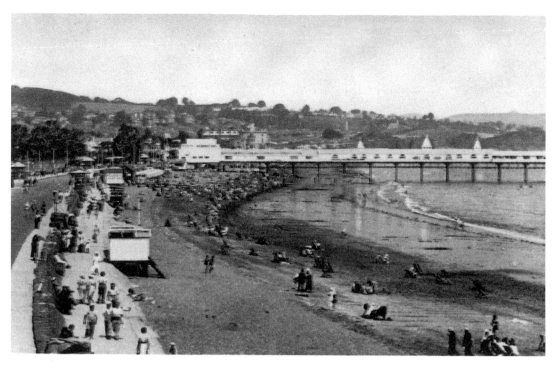

The Pier

Completed in 1897, the original pier was 780 feet long (40 feet longer than the present pier) and included a billiard hall at the end. A bad fire in 1919 saw the pier fall into decline, and not until the 1980s was refurbishment completed.

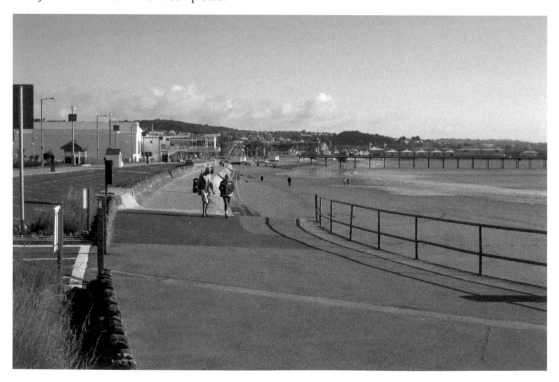

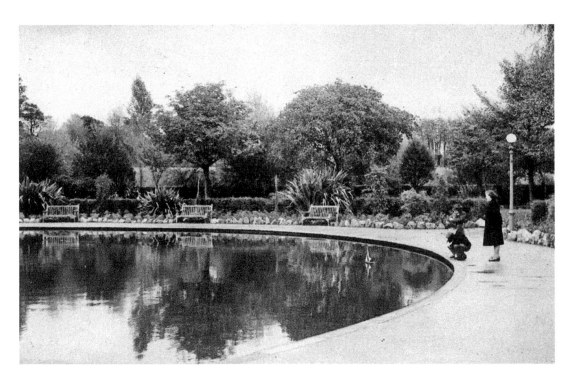

Victoria Park

The stream running through Victoria Park is man-made, the remains of the mill leat; the last watermill here was demolished in 1870. The shape of Victoria Park was largely dictated by the dykes and drains that brought the water from the mill to the sea.

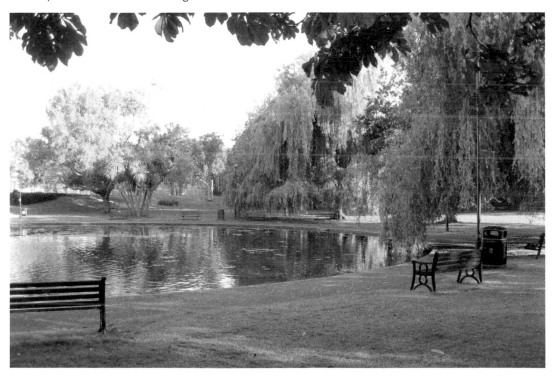

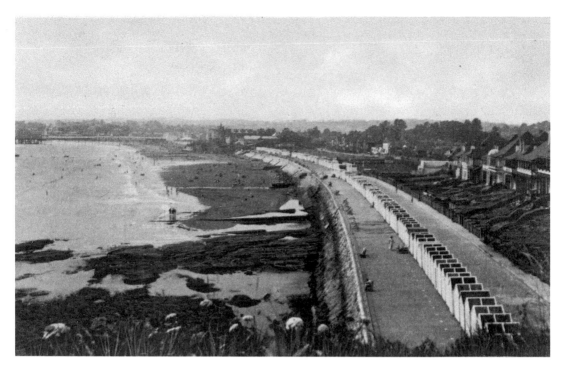

Preston Sands

There is little change in the buildings and beach huts as seen from the cliffs at the northern end of Preston Sands, Paignton. However, the old sewage outlet, more easily seen by the sandy line in the water on the new image, was closed off many years ago.

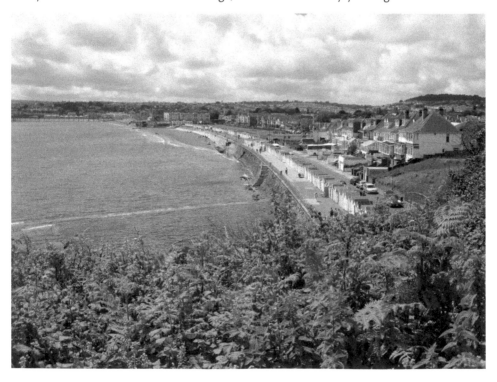

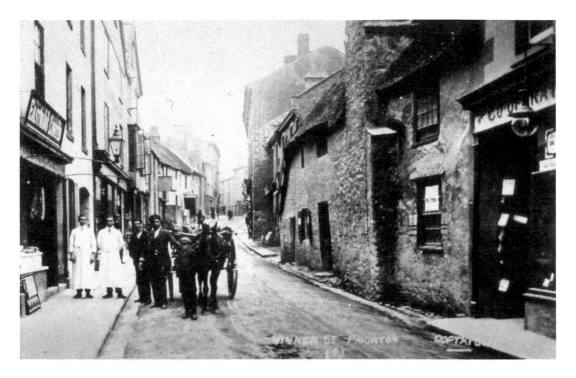

Winner Street, c. 1870

This street marks the former main street of old Paignton, although today, with the land reclamation of the nineteenth century, it stands half a mile from the shoreline. Early records of 'Wynerde Street' demonstrate that it was originally named for its vineyards – an indication that the mild climate is not confined to the modern era.

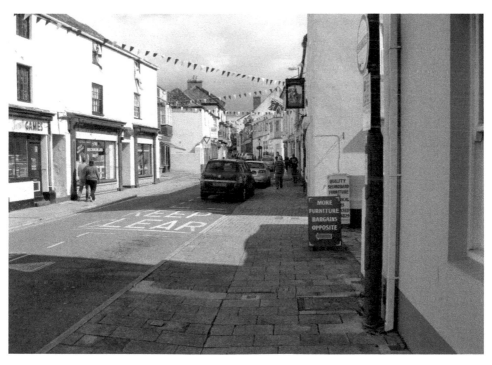

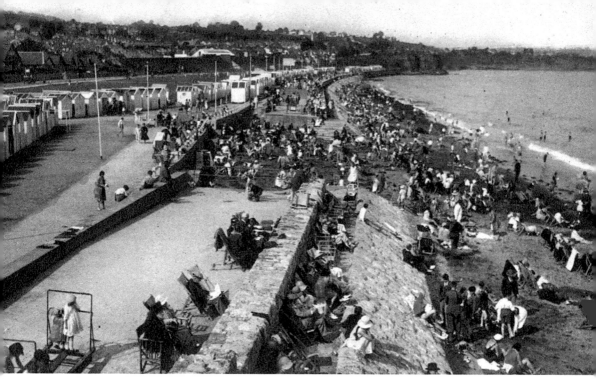

Kirkham Stream

Preston Sands extends for approximately half a mile. Rocky towards the northern end, it is also where the mile-long Kirkham Stream discharges into the sea.

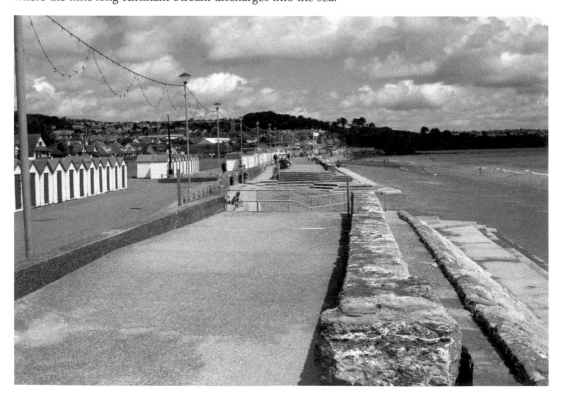

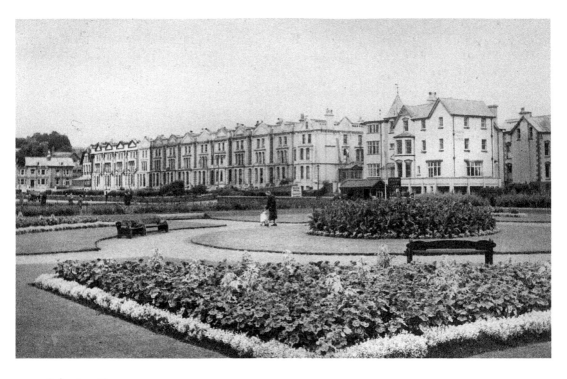

Paignton Green
Formerly known as the Rest Gardens. While the hotels in the background have hardly changed, the floral foreground is now occupied by a brand new crazy golf construction.

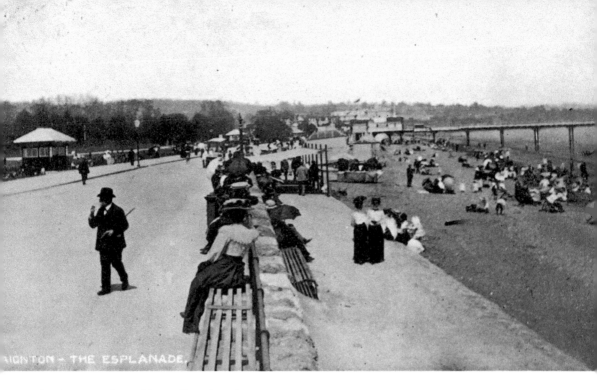

AIGNTON ~ THE ESPLANADE.

The Promenade and Roundham Head

The Promenade at Paignton with the original pier, before the fire, is seen in the background above, while below we see the peace and quiet of Fairy Cove with the sandstone of Roundham Head in the background.

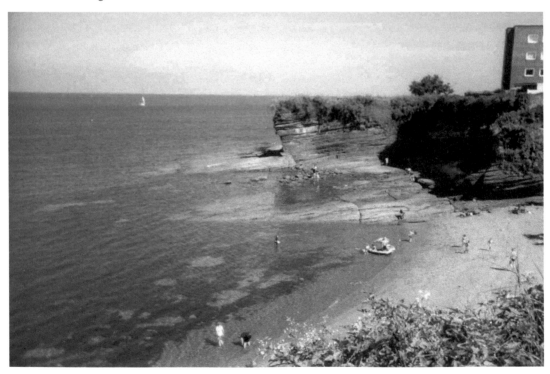

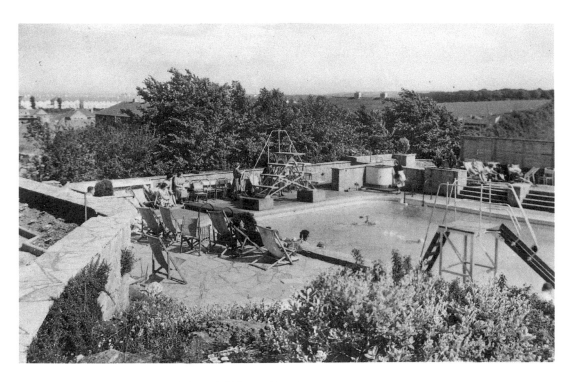

Devon Coast Country Club and Oldway Mansion

The swimming pool at the former Devon Coast Country Club, although it was never anywhere near the coast, welcomed many guests over the years. Perhaps some moved in the same circles as the Singer family, whose fame and fortune from their sewing machine enabled them to build such ostentatious homes as Oldway Mansion.

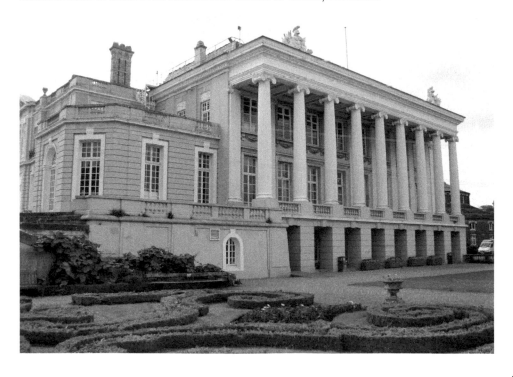

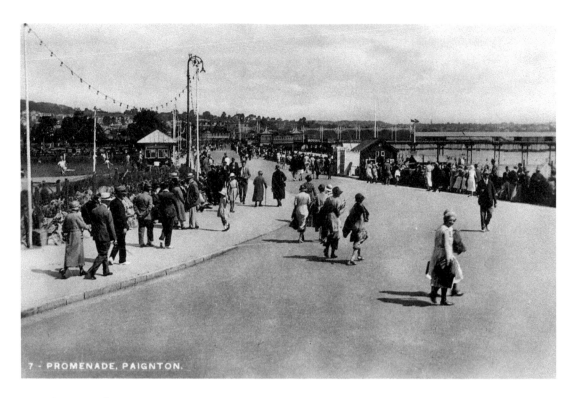

7 - PROMENADE, PAIGNTON.

Promenade

The Promenade at Paignton, seen shortly before the beaches of Britain were deserted during the Second World War. The pitch-and-putt course atop Roundham Head offers some fabulous views across the bay.

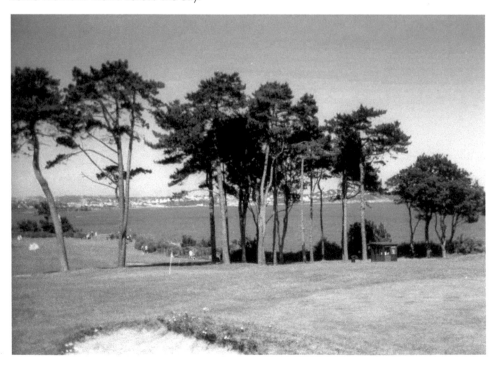

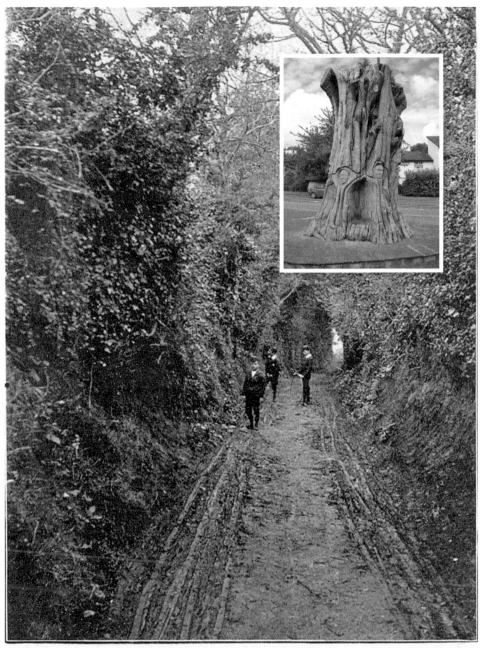

LOVERS' LANE, PAIGNTON.

Lovers' Lane and the Monterey Cypress
There is no known record of an official Lovers' Lane, hence this probably represents a local name and the location is unknown. This is not the case with the tree stump of the 140-year-old Monterey Cypress. It was in danger of collapse having succumbed to a disease. A campaign to keep it failed but resulted in bystanders receiving slices as keepsakes, while the largest pieces were taken to Paignton Zoo as toys for the elephants. Now carved with faces and seats, it remains a landmark.

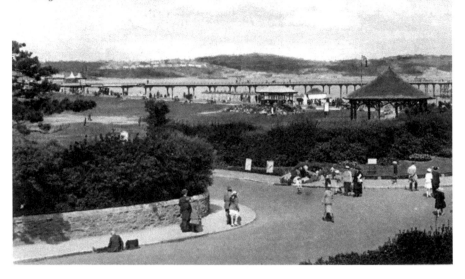

Sands Road

View from Sands Road looking at its junction with Esplanade Road and Roundham Road. There has been very little change apart from the removal of the bandstand and nearby bushes.

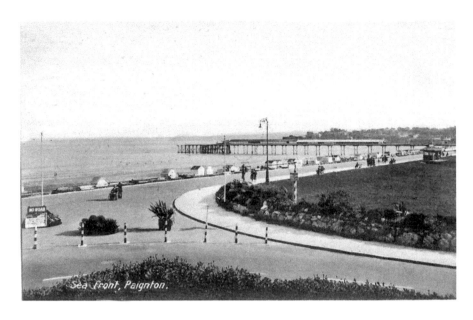

Berry Head

The view from Redcliffe Lodge, looking south towards Berry Head. In Edwardian times Paignton Green had numerous flower beds interwoven with pathways, which would have been thronged by gentlemen and ladies engaged in the popular pastime of 'promenading'.

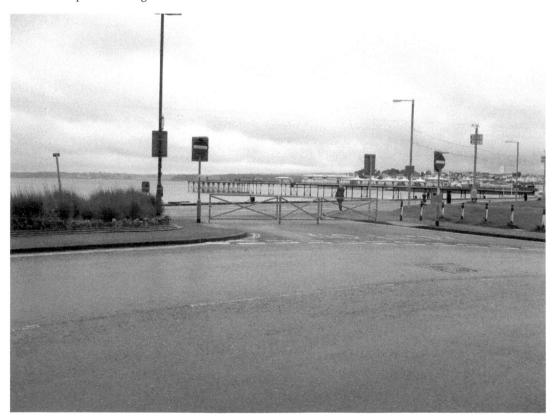

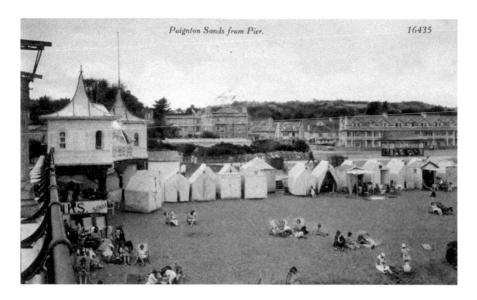

Paignton Sands from Pier. 16435

Attractions at Paignton Green

While the hotels in the background remain, other attractions and priorities change over the years. Once it was bathing tents, deckchairs and knotted handkerchiefs as headgear; today there is no sign of a deckchair as a rollercoaster is erected on Paignton Green. Yet to the right, the shelter remains, one of half a dozen that have been located along the Promenade for almost a century.

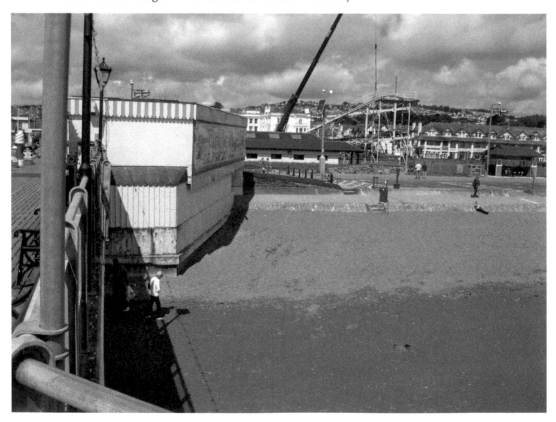

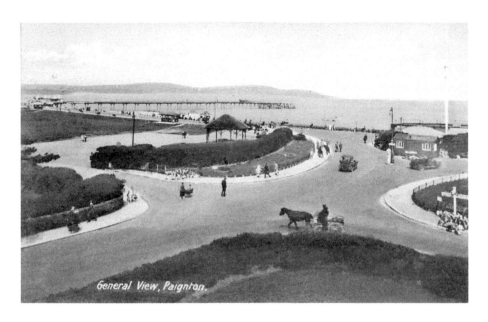

General View, Paignton.

Geoplay Park

An early image taken from Sands Road, with Esplanade Road to the left and Roundham Road to the right, also shows the pier with a sloping landing stage, allowing passengers access to vessels whatever the height of the tide. In the twenty-first century the Geoplay Park is an attraction for children while representing the various geological ages the region has seen.

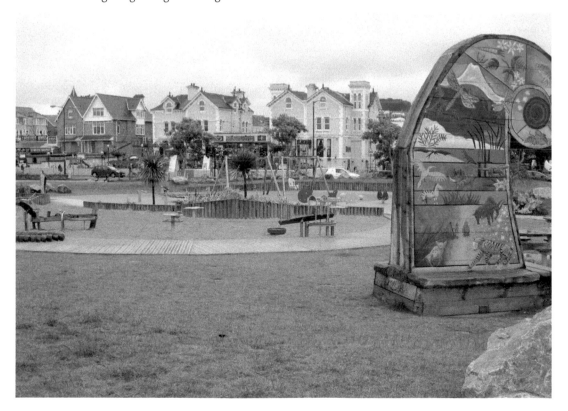

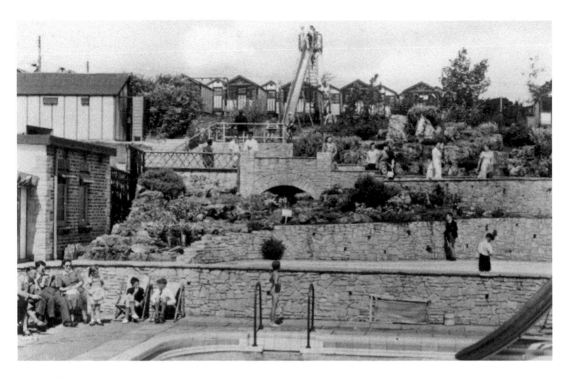

Oldway Mansion

At Devon Coast Country Club the deckchairs to the left of this image are occupied at the side of the swimming pool. Look closely and note the three males, one still of school age, who are all wearing ties! Below, Oldway Mansion has been used as the town council offices after the council purchased the building in 1946 for £46,000, less than a quarter of the original cost of building the house.

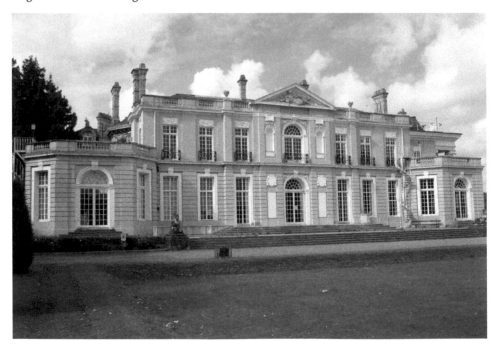

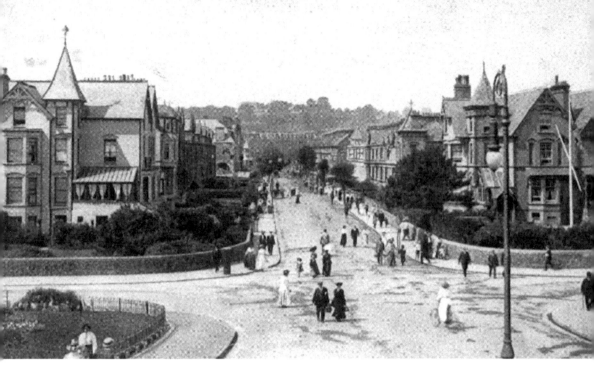

Grockle Alley

Torbay Road, Paignton, as it appeared before the First World War. Today it is filled with shops aimed at tourists, selling fudge, rock, and traditional trinkets. It is referred to by locals as Grockle Alley, 'grockle' being the dialect word for 'tourist'.

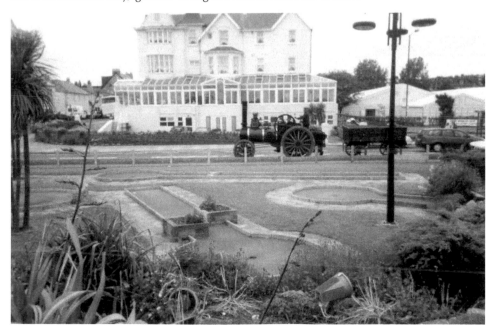

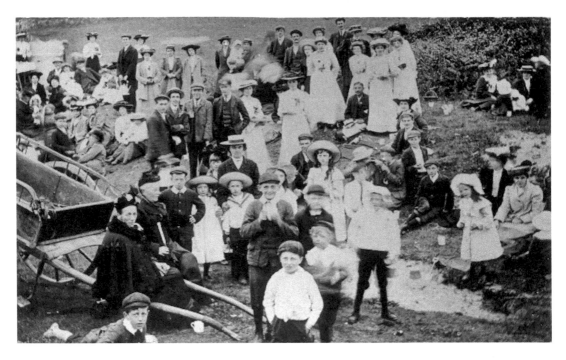

Holidaymakers

A group of Paignton holidaymakers; the image is thought to have been taken in 1905. Doubtless brought here by horsepower, they would have been mightily impressed by the Stanley Model Ex steam car built two years later. One of only three such cars in the country, this example visited the Torbay Steam Fair in 2012.

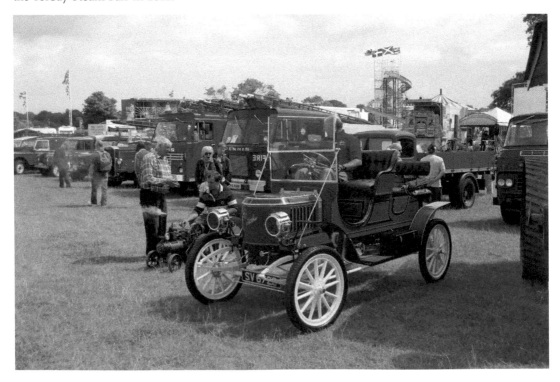

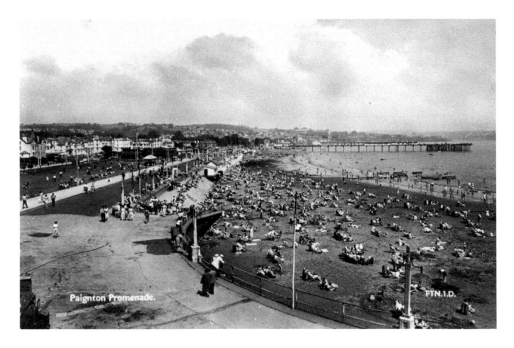

Beach Huts

The view along the Promenade from Paignton Club. Some of these holidaymakers will have rented a beach hut, still available in the twenty-first century. Perhaps some of these huts – these examples are at Broadsands – are members of the official Mad Hutters Club.

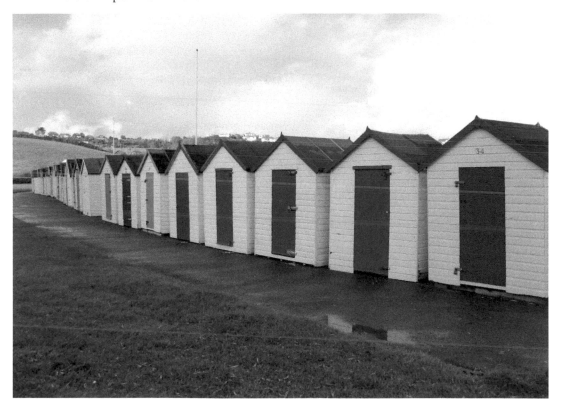

Gerston PLace

The large houses of yesteryear have proven invaluable when it comes to finding premises for use as guest houses. The lower photograph appears older but these murals are still visible in Gerston Place, Paignton.

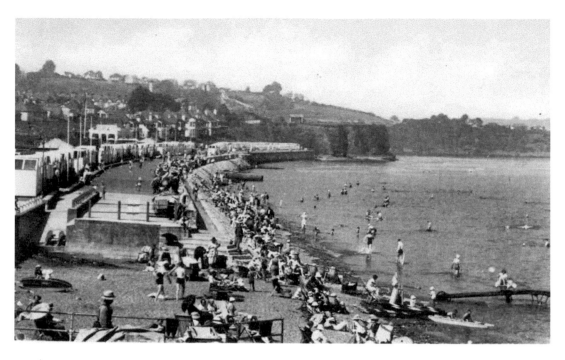

Preston Sands

Bathing tents on Preston Sands have been replaced by beach huts.

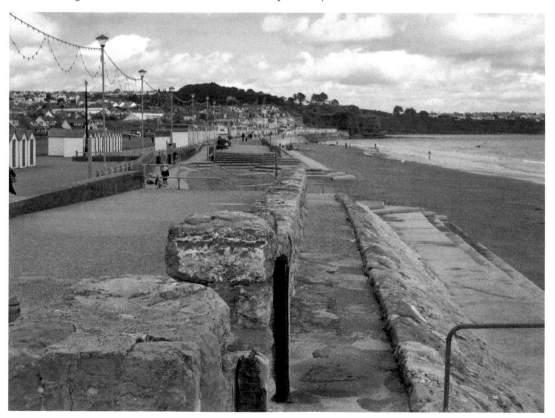

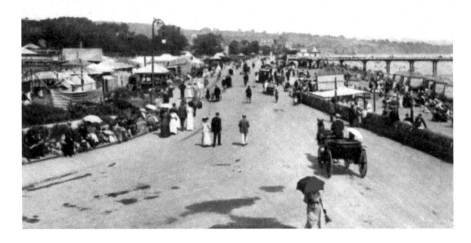

Paignton and Hollicombe

The view along the front at Paignton has changed little over the decades. Below, the view from above the next beach at Hollicombe, looking back over the railway that brought many of the visitors in the upper image to the sandstone outcrop separating this from Preston Sands.

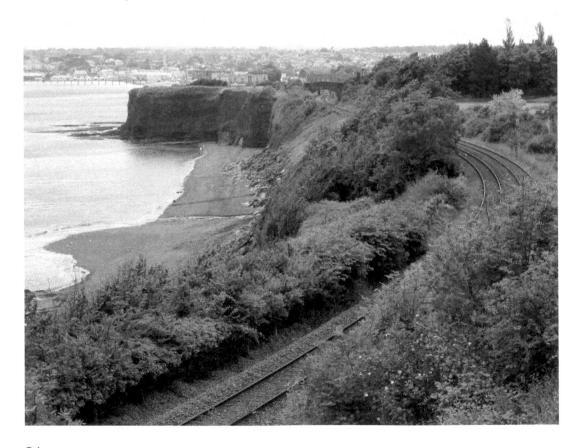

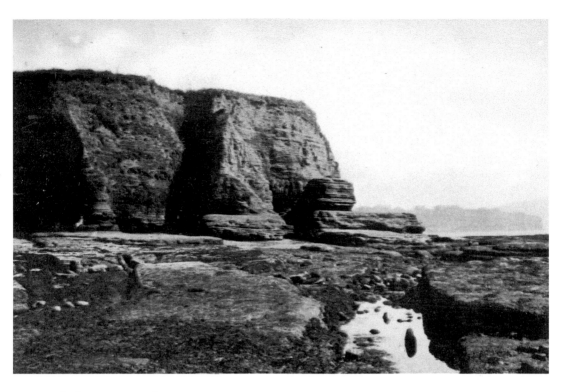

End of Preston Sands
The sandstone outcrop marks the end of Preston Sands. Both the beach and the gardens of Oldway Mansion will have been walked on many occasions by the Singer family.

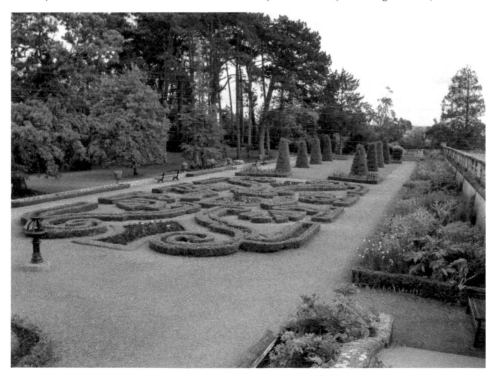

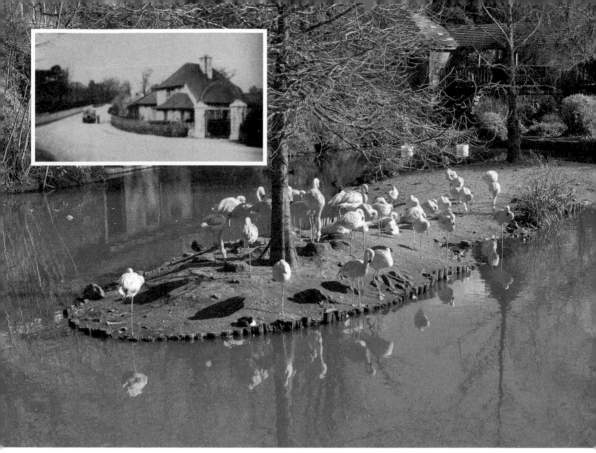

Primley House
Herbert Whitley, founder of Paignton Zoo, with the only known image of Primley House (*inset*), the entrance to the zoological gardens in 1930. Today one of the first sights is the flamingos.

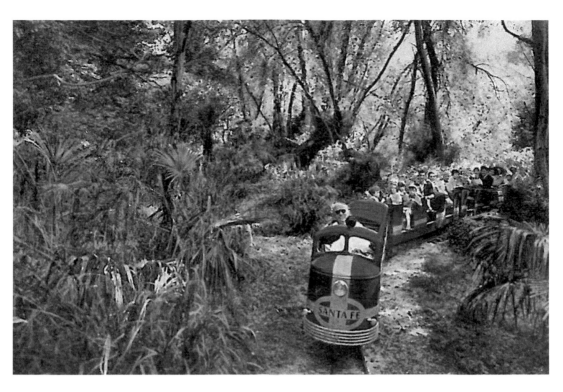

Paignton Zoo
Visitors ride the Jungle Train, although it does not pass the enclosure housing the African elephant, which Paignton Zookeepers named Duchess.

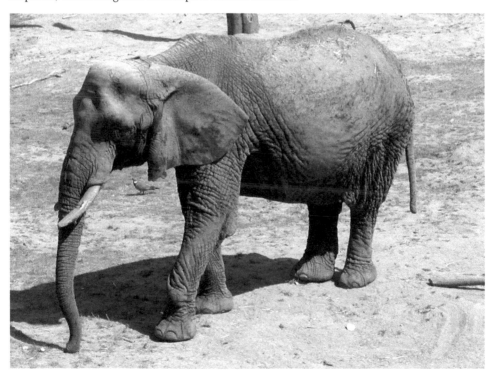

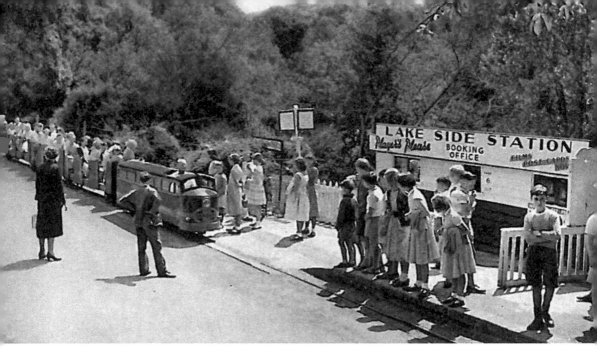

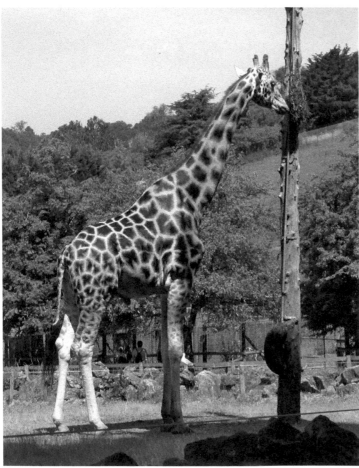

Jungle Train
The station at Paington Zoo, where passengers await the Jungle Train. The tallest inhabitant of the zoo today is a male Rothschild giraffe.

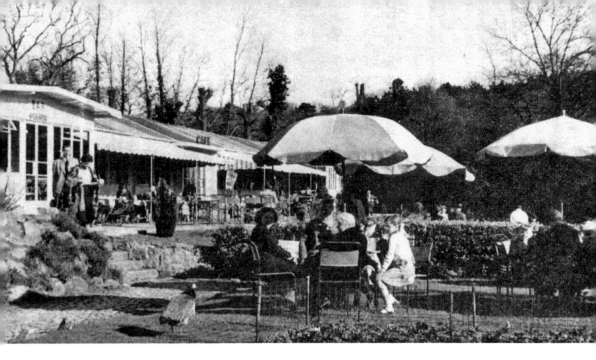

A Day Out
Visitors to Paignton Zoo enjoy refreshment at the cafeteria, probably eating a less balanced diet than the dwarf caiman.

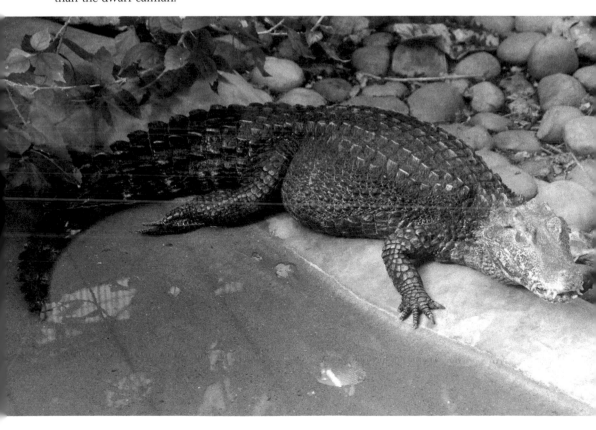

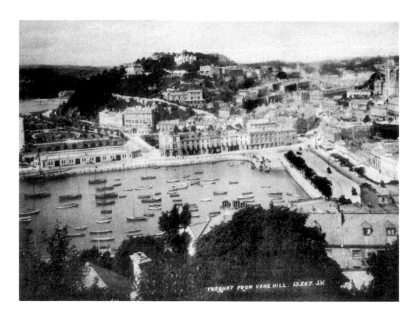

View from Vane Hill

A view over the original harbour and Waldon Hill from the higher Vane Hill. Clearly the basic street layout had already been fixed by the time this image was taken in the 1920s, as we would expect from a town laid out in the Victorian era.

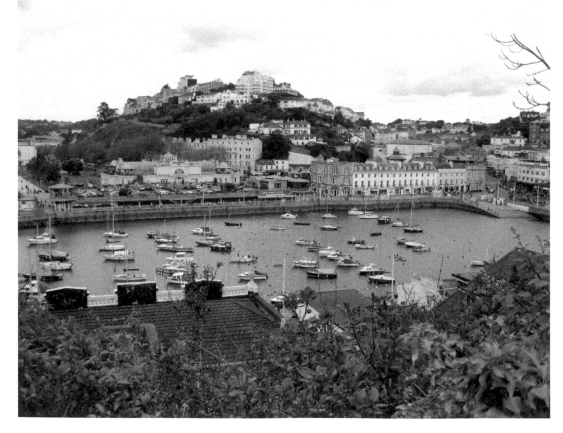

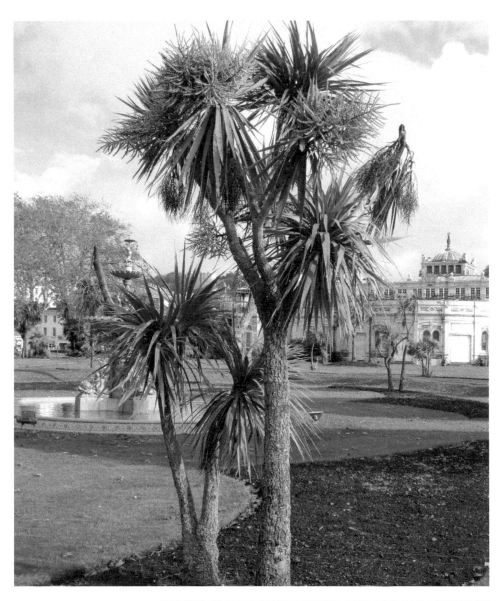

Fisherman's Walk
Given a much-needed facelift between 2007 and 2011, what began as Fisherman's Walk was officially known as the Royal Terrace Gardens as soon as soft lighting was introduced. In 1920 a local film company used these paths as the jungle setting for their film version of Warwick Deeping's *Unrest*.

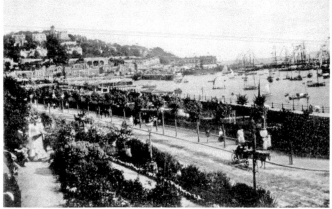

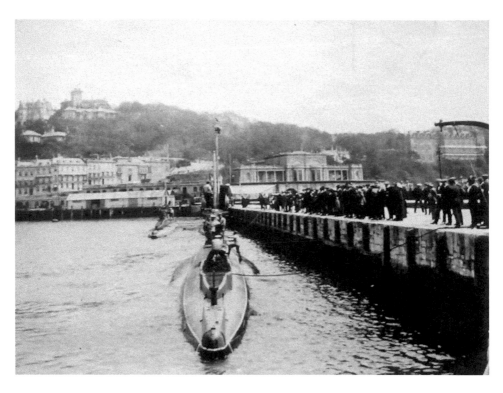

Torquay Harbour
During the Second World War a British submarine departs from Torquay Harbour. No sign of underwater craft in 2012, although the skyline is still recognisable beyond.

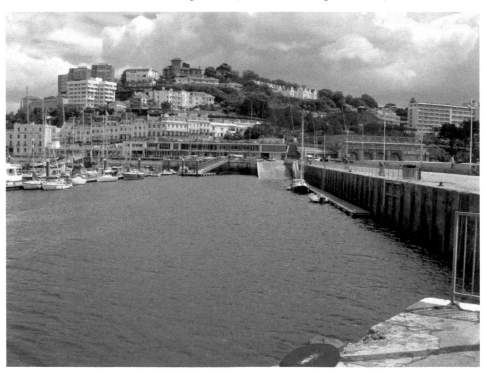

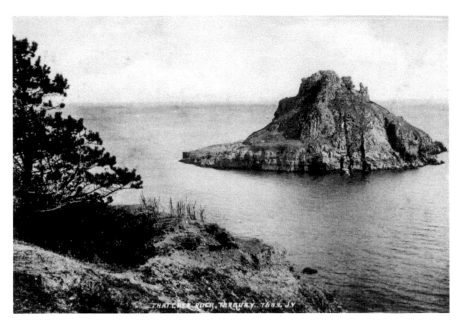

Thatcher Rock

The limestone isle known as Thatcher Rock, off Hope's Nose, Torquay, has the remains of a beach 25 feet above today's sea level. Torquay Rowing Club use this landmark for a series of annual 8 km races in the late spring.

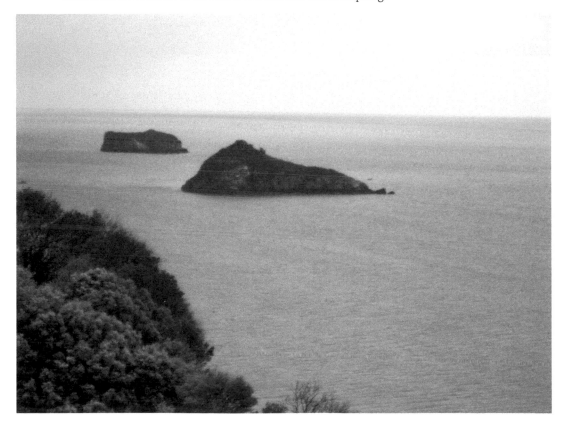

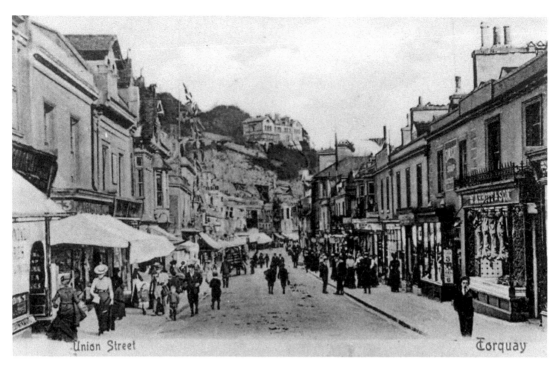

Union Street
Union Street, Torquay, in the early twentieth century was lined with shops; it is still a hive of retail activity today.

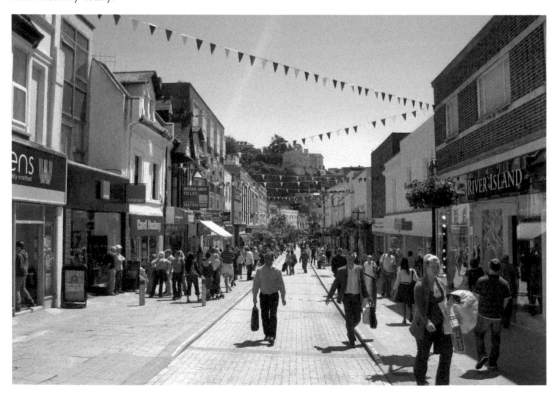

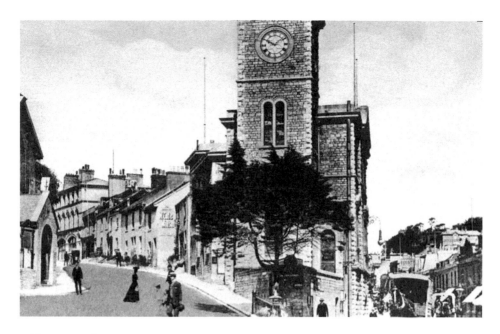

Old Town Hall

The old town hall has frontages on Abbey Road and Union Street, although these are at very different levels. Built in 1850, the clock was added nearly fifty years later. The building currently sees more visitors than ever – it is home to toilets for both sexes.

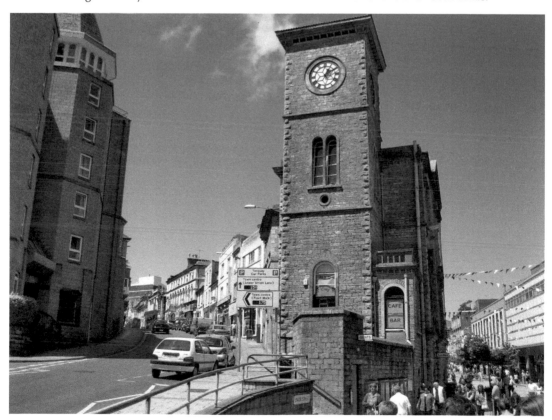

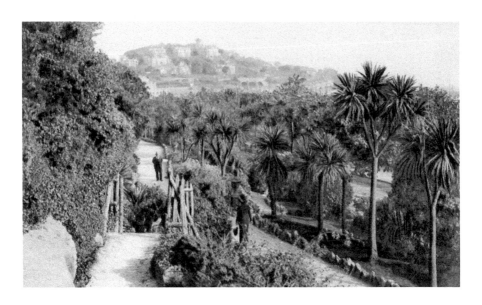

Royal Terrace Gardens
This early view of the Royal Terrace Gardens shows the 'exotic' species of flora, such yucca and bamboo, planted to enhance the impression of a mild climate. In 2007 it was discovered these trees and shrubs had severely weakened the rock face and the area was cordoned off as some three hundred tons of vegetation including trees, shrubs and overgrown scrub was removed.

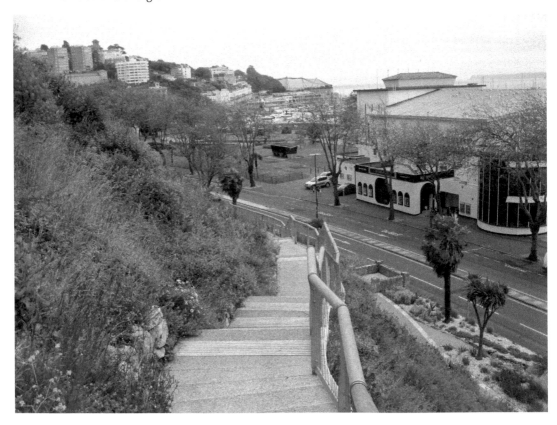

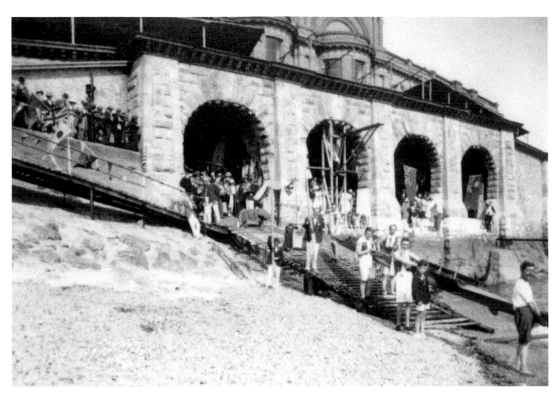

Torquay Rowing Club

Home to Torquay Rowing Club in the 1920s, it is still easily recognisable as the sea wall protecting the attraction Living Coasts, with its penguins, seals and numerous water birds.

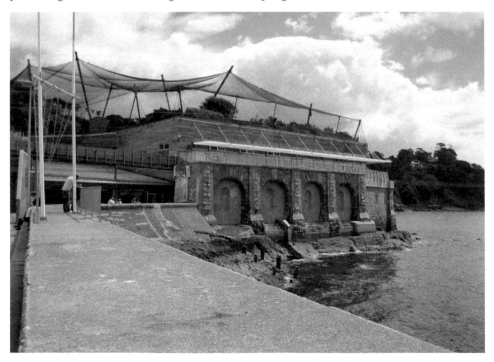

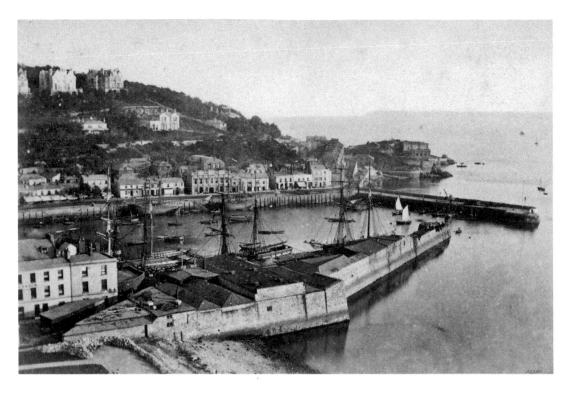

The Spanish Barn

Torquay Harbour from Waldon Hill in the 1870s. The Spanish Barn outside Torre Abbey is still here in the twenty-first century. It held 397 prisoners from the Spanish Armada in 1688; and was an old building even then, having been built in the twelfth century.

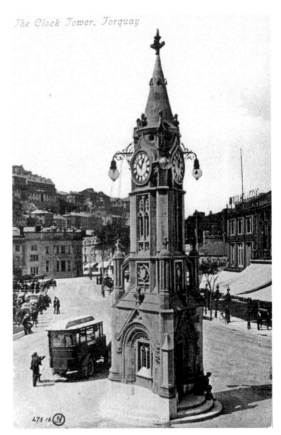

Memorial Clock Tower

Unveiled in 1903, the memorial clock tower in Torquay was paid for by subscriptions in memory of the late Richard Mallock, owner of Cockington and MP for Torquay. Refurbishment was completed in 2011 and the clock's bell was heard for the first time in seventy years.

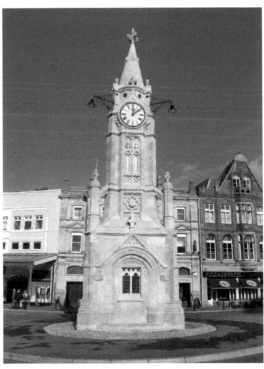

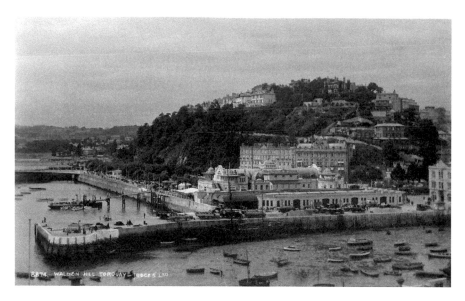

Quayside
Torquay Harbour from Vane Hill. The modern quayside can be seen taking shape.

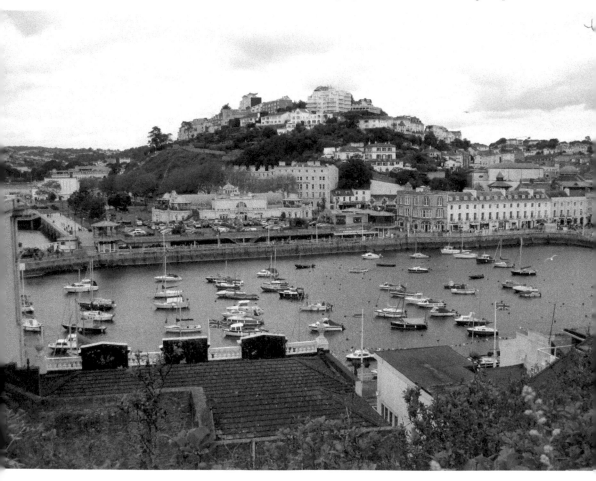

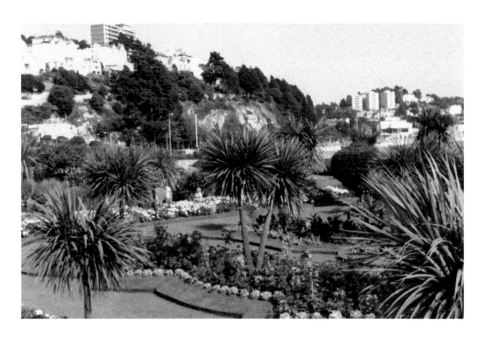

Cabbage Tree and the Princess Theatre

The Torbay Palm is actually *Cordyline Australis*, a native of New Zealand also known as the cabbage tree. The attraction of the walk in the early nineteenth century was its position just yards away from the Princess Theatre – a venue which has seen many famous performers over the years.

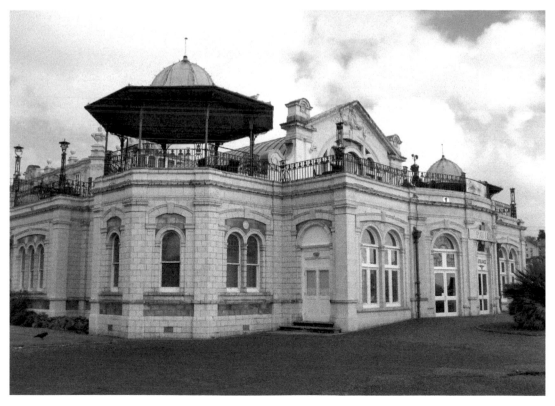

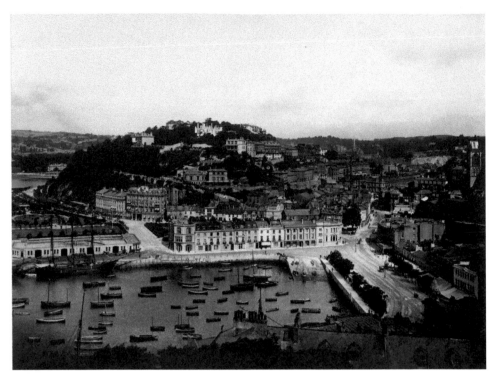

Harbour Vessels
Torquay Harbour has been a magnet for pleasure craft and working vessels for as long as it has existed.

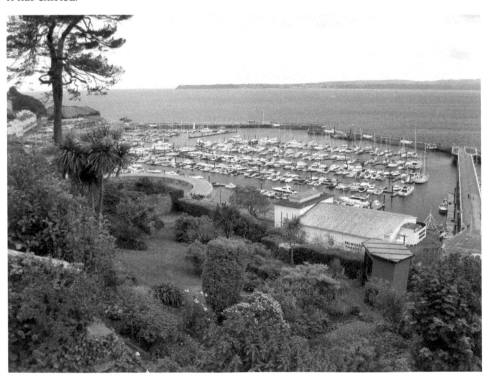

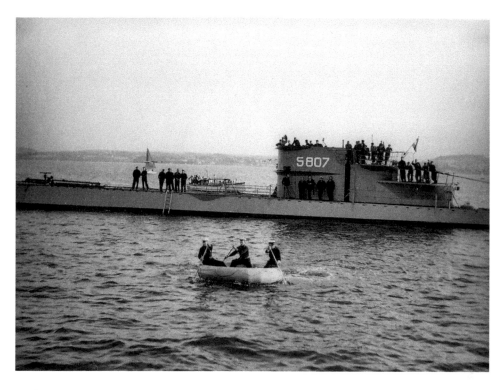

Torbay at War

During the Second World War the bay was patrolled by Royal Navy submarines. Today, these youngsters are given tuition on a sailing vessel moored near the mouth of Torquay's harbour.

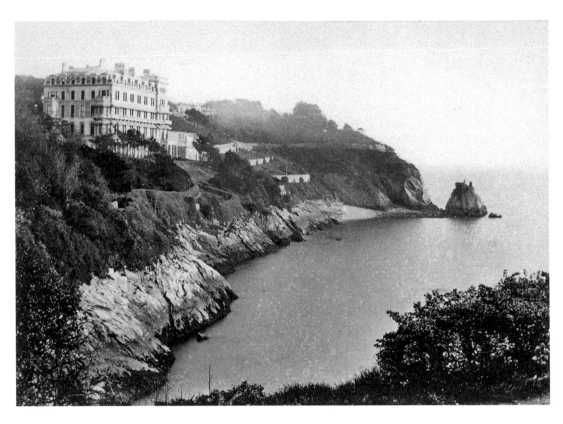

Imperial Hotel
The Imperial Hotel once had its own seawater pool.

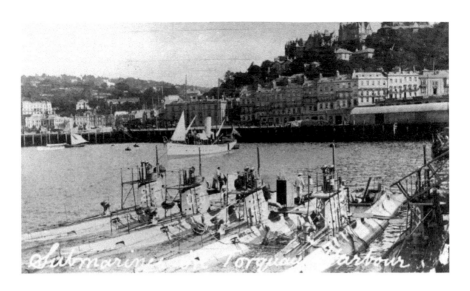

Submarines

A number of submarines moored in Torquay Harbour. These examples are thought to date from before the First World War. Today the numbers are greater and they are virtually all pleasure craft.

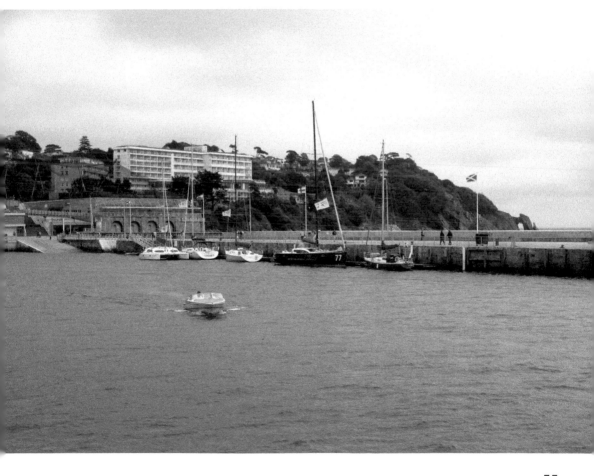

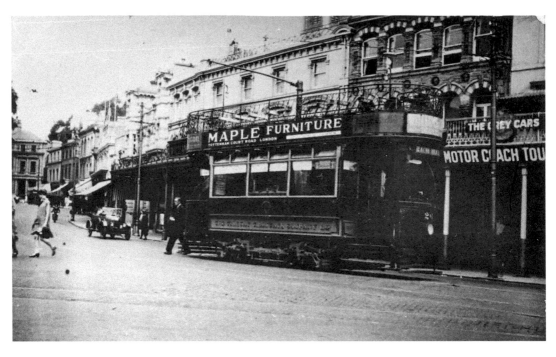

Cary Parade Trams
A tram pictured on Cary Parade, which otherwise has changed very little over the decades. The last tram ran between Torquay and Paignton in 1934.

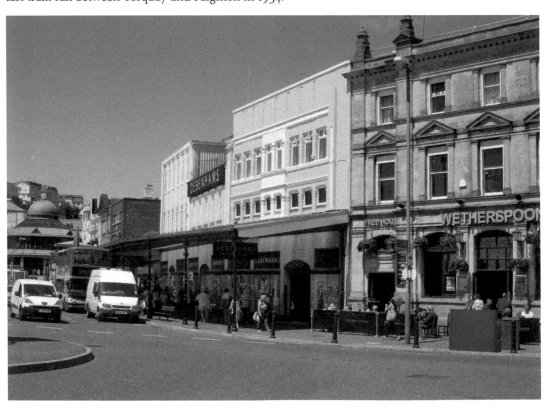

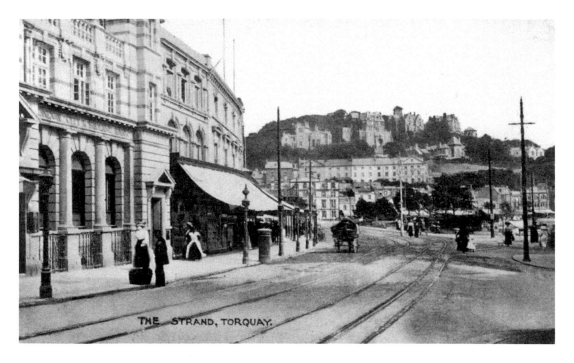

THE STRAND, TORQUAY.

The Strand and Cary Parade

Looking the opposite way, what appears to be a dual carriageway is actually two roads with two different names. The stretch of road on the right is known as The Strand, while the traffic heading away from the camera is travelling along Cary Parade.

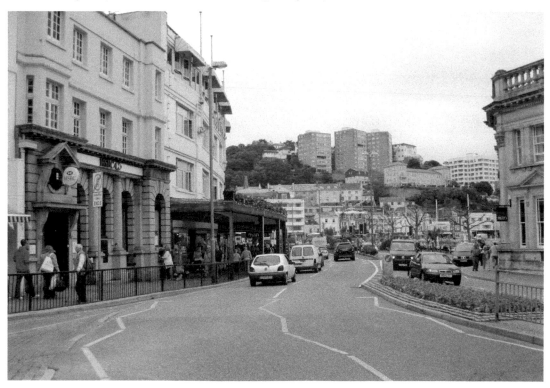

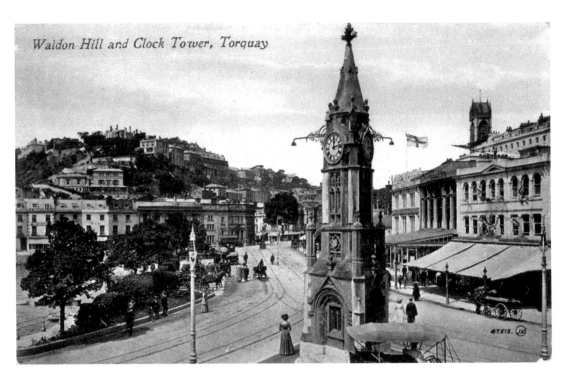

Waldon Hill and Clock Tower, Torquay

Tramlines and Clock Tower

Tramlines show the route taken by the trams. While the trams are long gone, the clock's bell is ringing out once more in the twenty-first century.

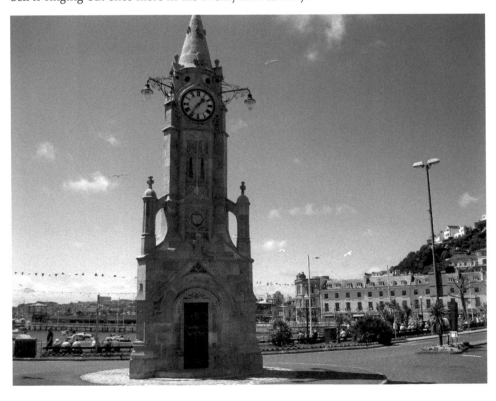

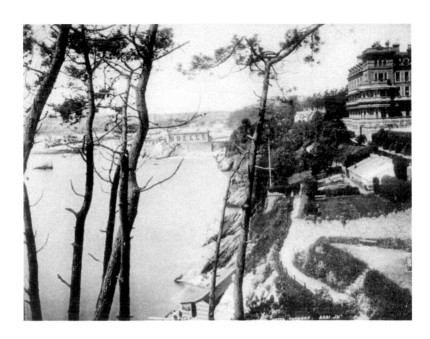

Imperial Hotel and Anstey's Cove
The Imperial Hotel, probably at the start of the twentieth century. The later image was taken further north, near Anstey's Cove.

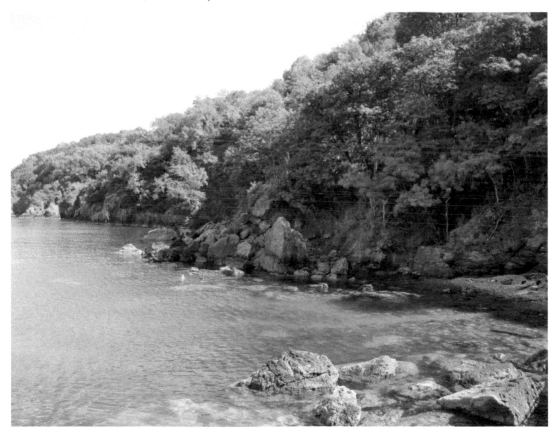

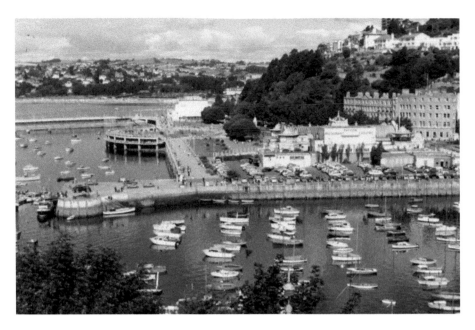

Harbour Wall

The new harbour wall stretches out in the background, from where the new image offers a good view of the hill.

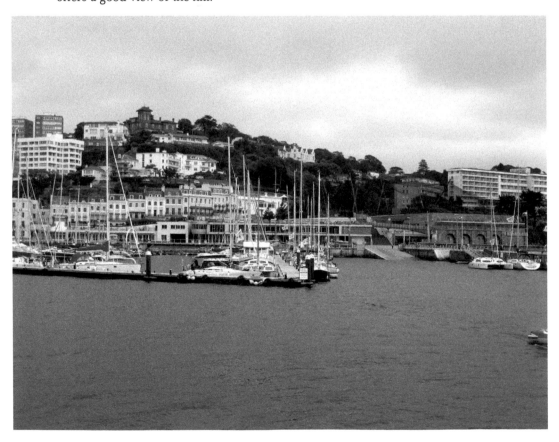

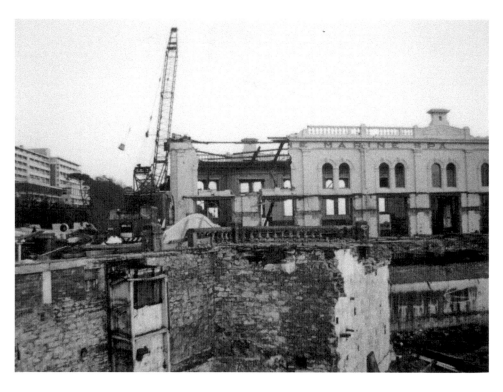

The Spa and London Bridge
The Spa is demolished in 1971 in the photograph above. Along the coastline to the north the sea erodes the arch known as London Bridge.

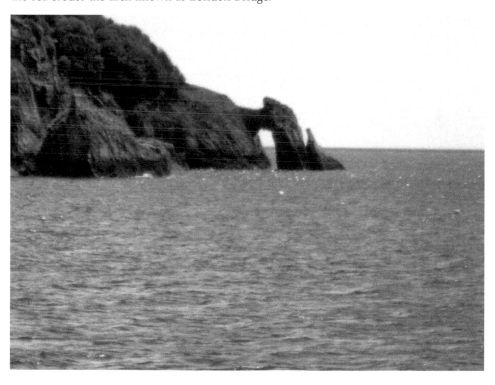

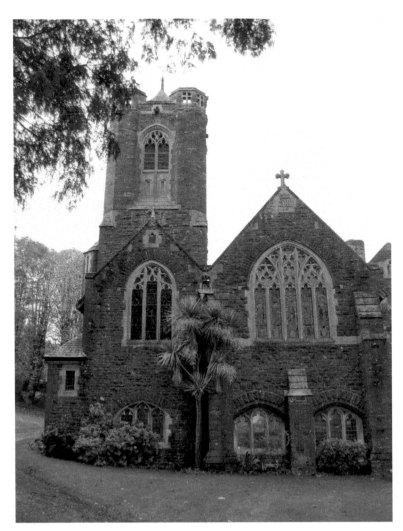

St Matthews, Chelston
One of the places of worship around Torquay is St Matthews, Chelston – an island of green in an otherwise residential area.

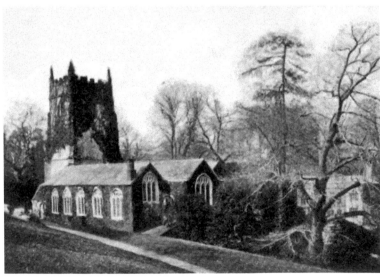

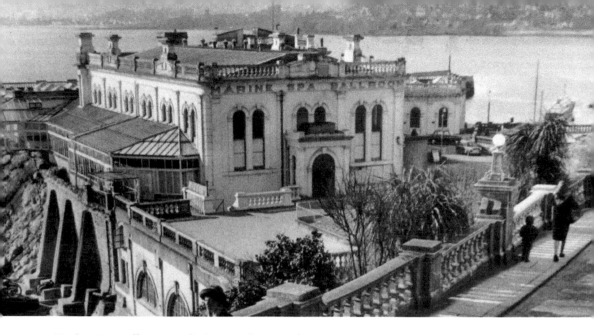

Marine Spa Ballroom and View to Livermead
The Marine Spa Ballroom is pictured in 1965, while the modern view is towards Livermead from the top of the cliff walk at Torquay.

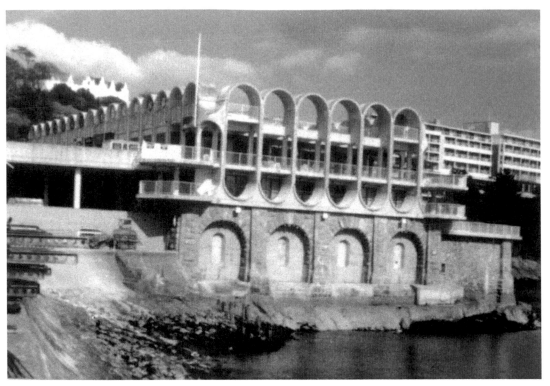

Coral Island and Cliff Walk
When the Spa closed it was
replaced by Coral Island,
the area now occupied by
Living Coasts. Overlooking
the Princess Theatre is the
newly opened Cliff Walk, a
worthwhile climb considering
the views from the top.

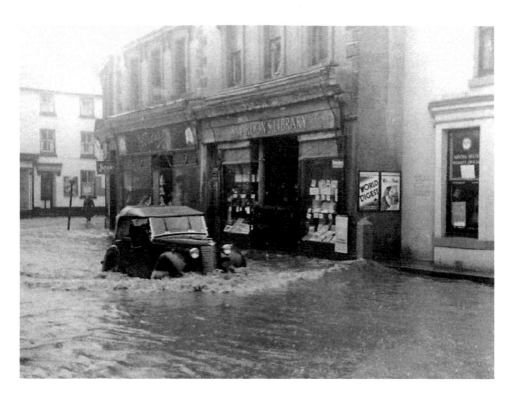

Brixham Floods
The terrace of houses shows how steeply the land rises from sea level at Brixham Harbour. This makes the floods of 1930 even more amazing considering the old Smardon Library was to be found in Bolton Street, near the present-day library and museum.

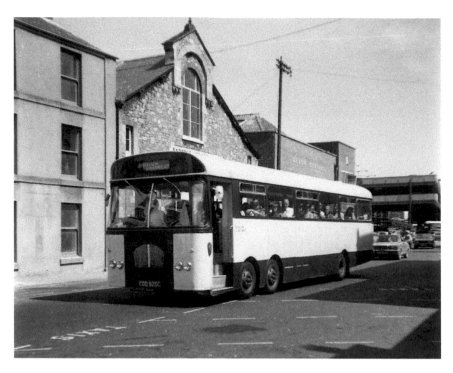

Brixham Buses
Brixham's buses are too big to cope with the narrow streets and tight corners near the quayside and in the town, and so the terminus is more than a quarter of a mile from the water.

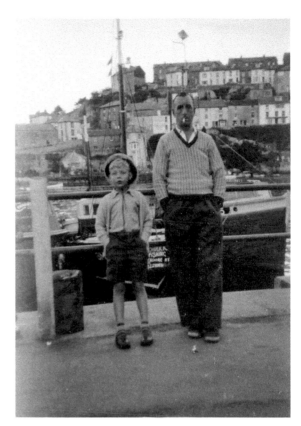

Brixham Quayside
Fashions have certainly changed since these two stood on the quayside to have their photographs taken – note all four hands thrust deeply into pockets. Beyond, Brixham's buildings have hardly changed at all.

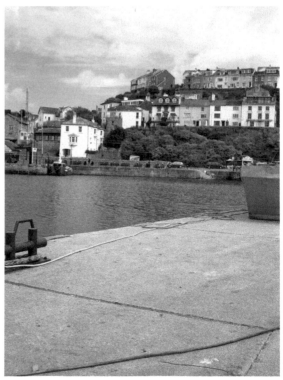

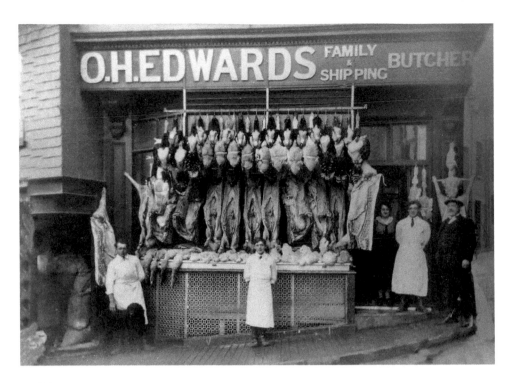

Middle Street

The view from the Strand up Middle Street shows this is a tight corner and a narrow street even in the twenty-first century. However the earlier image is of the butcher's shop of O. H. Edwards, which was on the end of the premises on the left, effectively reducing the width of the mouth of Middle Street by at least half.

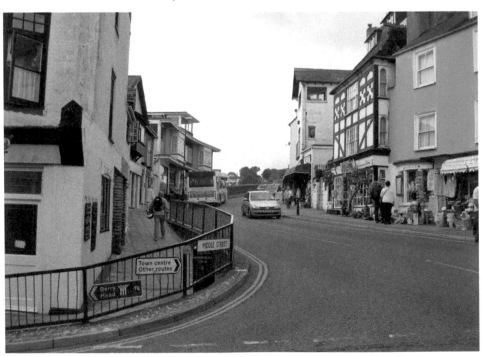

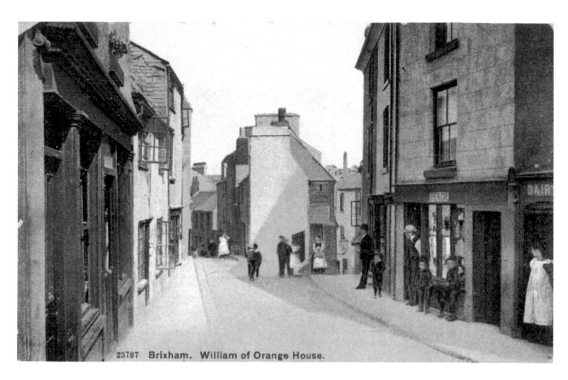

23787 Brixham. William of Orange House.

Higher Street, Brixham
William of Orange House is in the centre with Peach's store on the right. The area is now almost all residential.

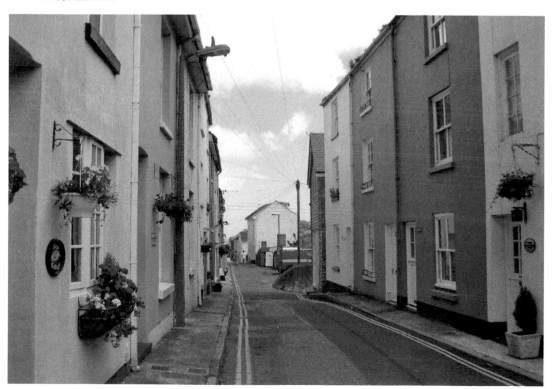

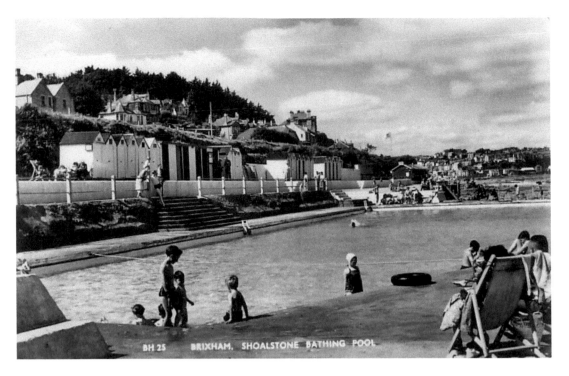

Shoalstone Pool

This seawater bathing pool at Brixham has long been a popular haunt for young children. In the spring of 2012 it looked as if the area was to be fenced off but, shortly after this photograph was taken, the local authorities had a change of heart and lifeguards were on duty once more.

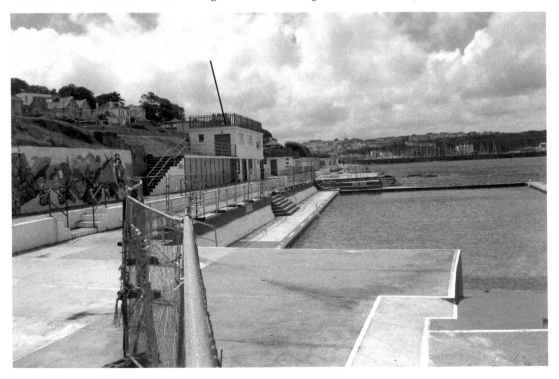

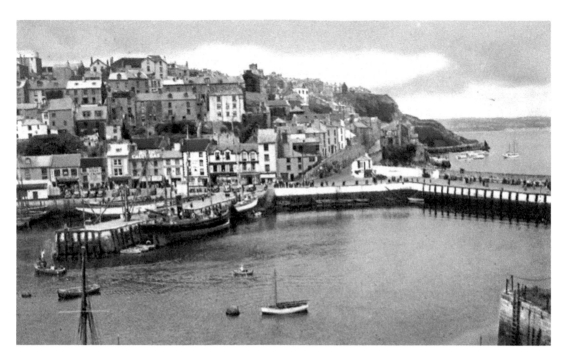

Inner Harbour
Brixham's Inner Harbour and Overgang have changed little.

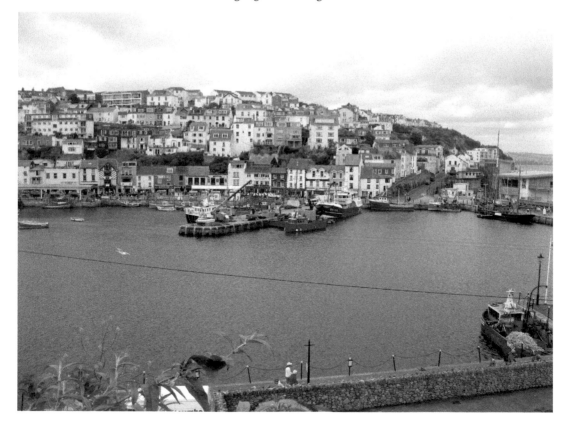

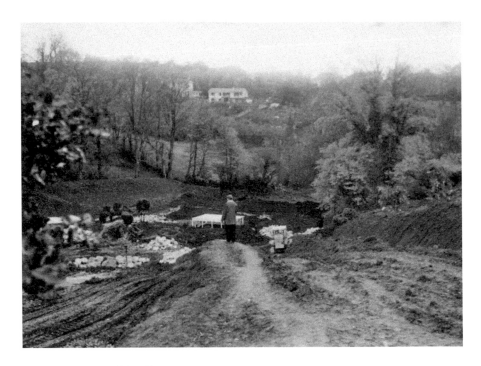

Babbacombe Model Village

Around 1960 the dream of a model village at Babbacombe began to take shape, although there was still a lot of work required before the collection of buildings and mud would finally resemble a pretty village with a railway running through it. Nowadays, tourists and locals alike come to admire this labour of love, as seen in the new image below.

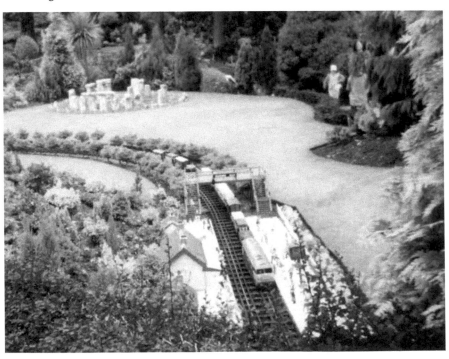

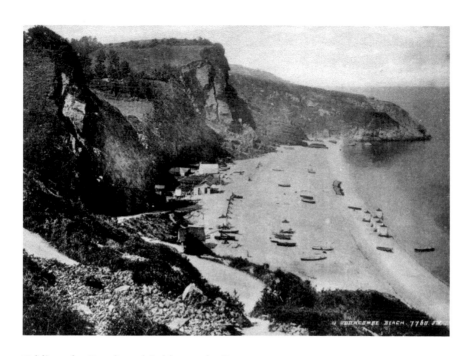

Oddicombe Beach and Babbacombe Downs

Today, one end of Oddicombe Beach is closed off owing to the danger of falling rocks from the crumbling cliff face. However, as these views from Babbacombe Downs show, this is not a recent problem. The vegetation-free scar down the cliff face is quite evident, yet the crowds below seem oblivious to the dangers.

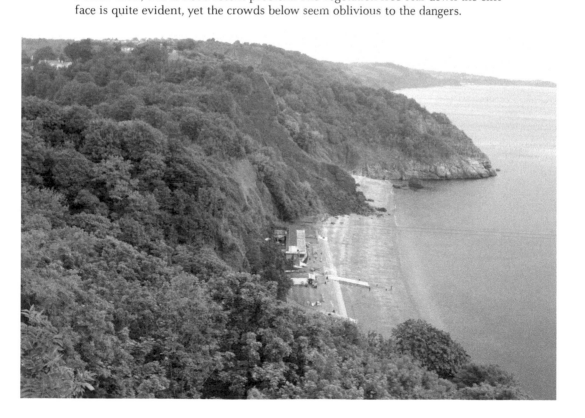

Model Village

Early visitors to the model village enjoy an ice cream. While the bus bringing visitors to the model village appears older than the attraction, on closer inspection the registration reveals this is a 1966 model.

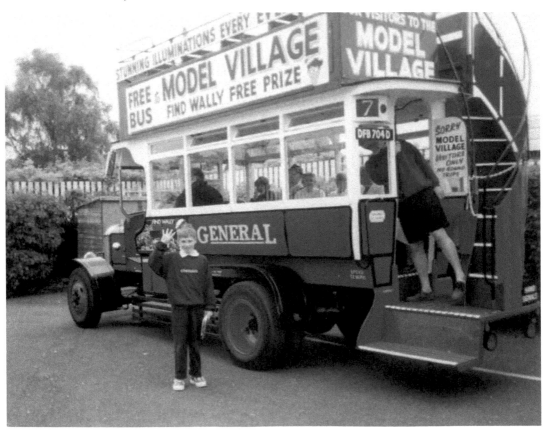

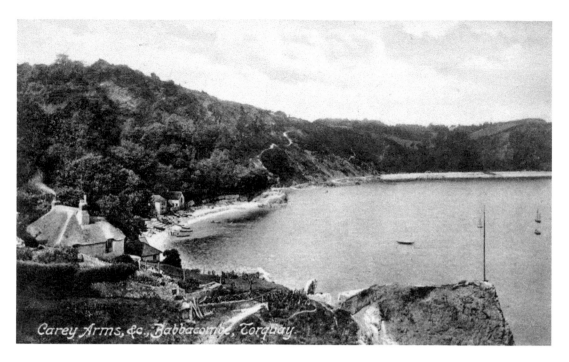

Carey Arms, &c., Babbacombe, Torquay.

The Cary Arms

The Cary Arms was named after the influential family, who moved to Torquay in 1662 when Sir George Cary bought much of the land between here and Cockington. Today the Cary Arms is justifiably proud of its listing in the *Michelin Guide*.

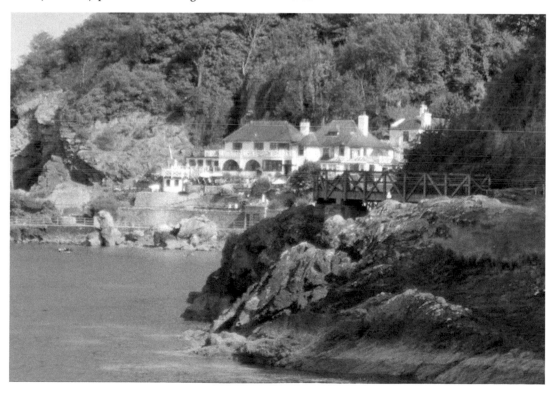

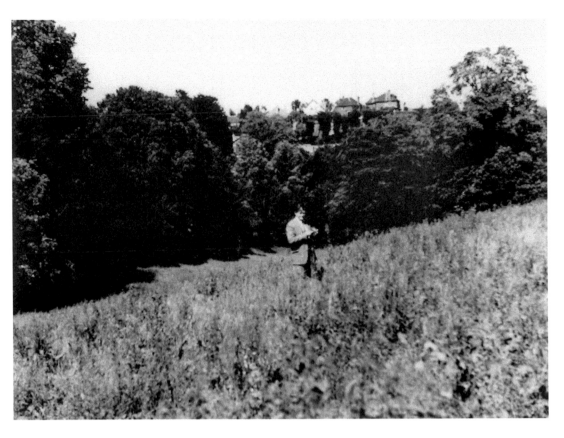

Before the Model Village
Tom Dobbins surveying the field around 1960. The area was to become one of the most popular visitor attractions in South Devon, some arriving by open-top bus to view Babbacombe Model Village.

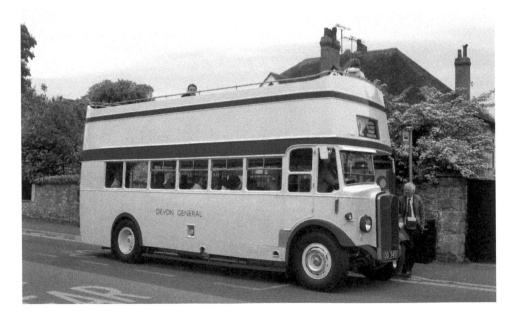

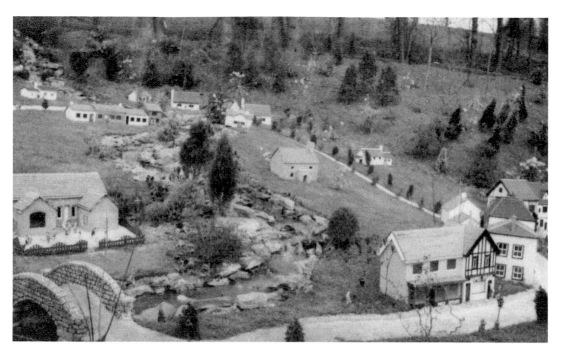

Early Model Village
The model village in its earliest days, prior to opening in spring 1963. It has grown and evolved over the last five decades and will continue to do so.

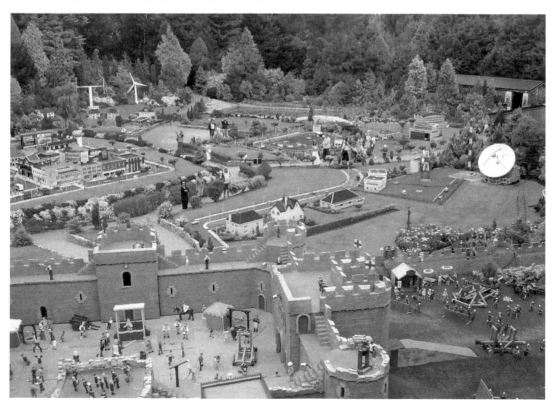

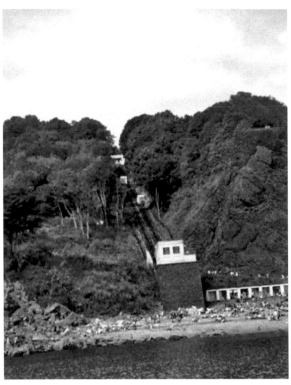

Cliff Railway
The Cliff Railway from Babbacombe Downs to Oddicombe Beach has been running on and off since it was opened in 1923 at a cost of £15,300. The earlier image was taken from the water, the modern view from the upper station.

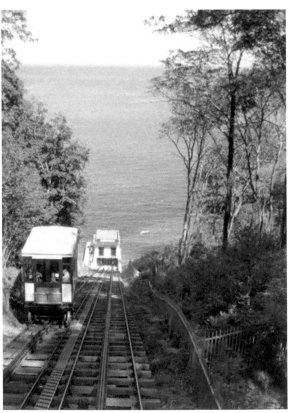

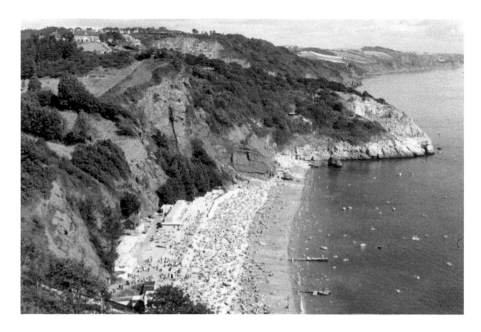

Oddicombe Beach

Oddicombe Beach drew visitors even before the cliff railway was opened. The dangers of the crumbling cliff face are evident in this modern image.

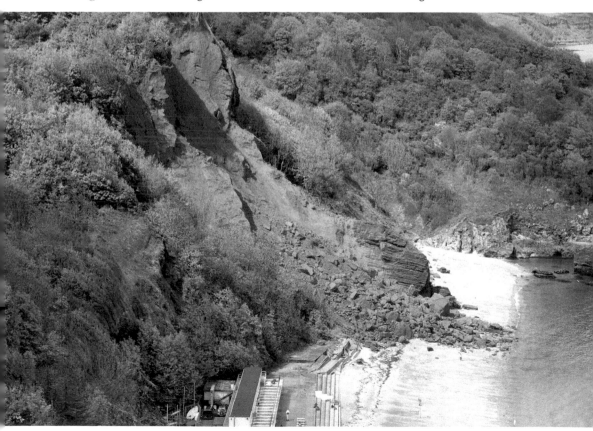

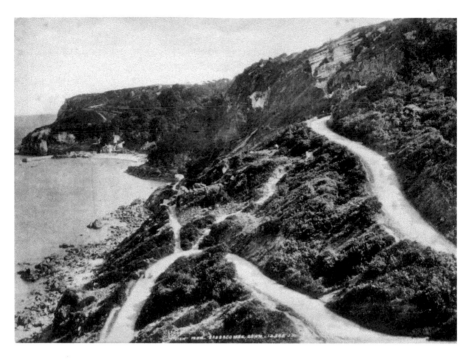

View from Babbacombe Downs
Today the view of the winding path from Babbacombe Downs to the shore is hidden by the trees and shrubs planted to break up the otherwise stark cliff face.

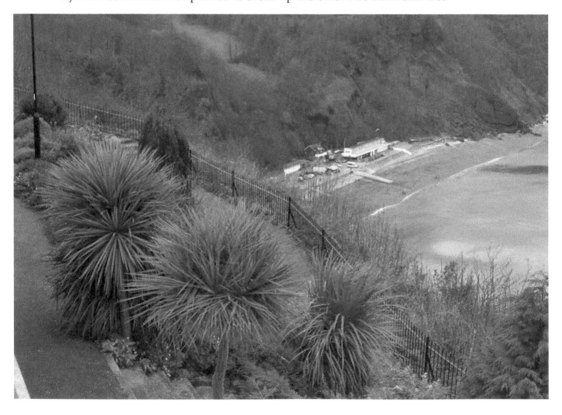

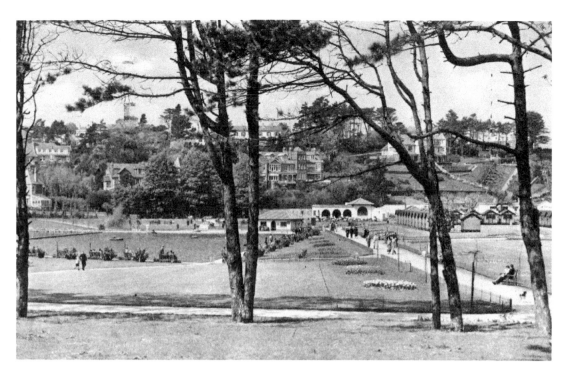

Youngs Park

The basic layout of Youngs Park in Goodrington remains the same. Only a few trees have gone.

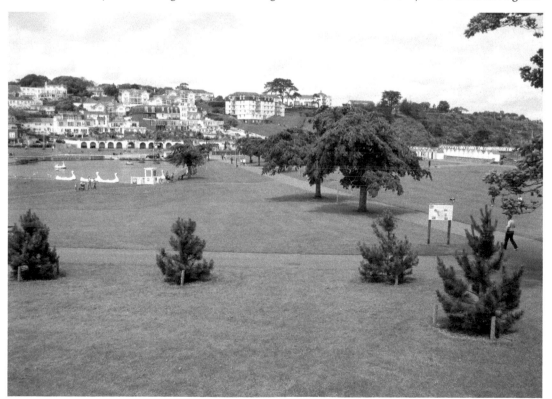

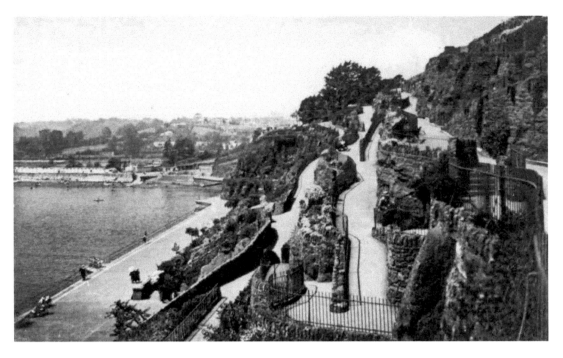

Path at Goodrington

This path at Goodrington was planted with specimens donated by what was Primley Zoological Gardens and is now Paignton Zoo. After dark the cliff face is brought to life by soft lighting in an array of colours.

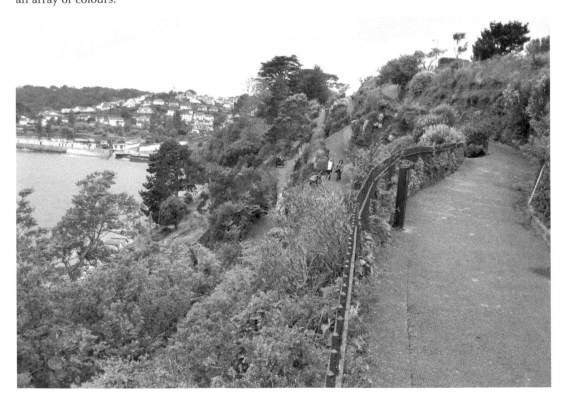

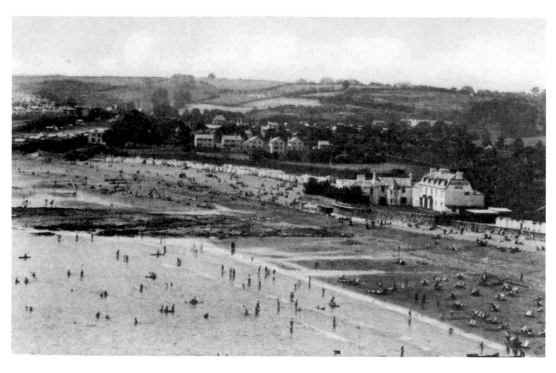

Goodrington Beach
From the top of Roundham Head is a view of Goodrington's beach. Beyond is Youngs Park – to this day, nobody has any idea how it got its name.

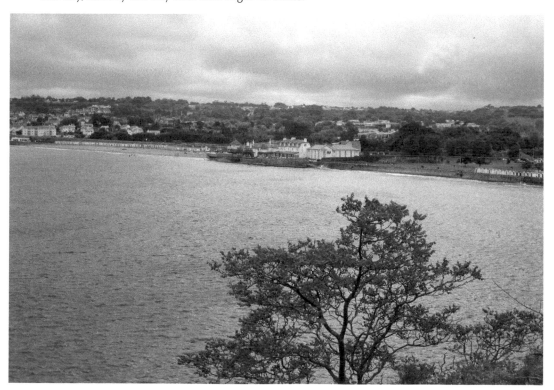

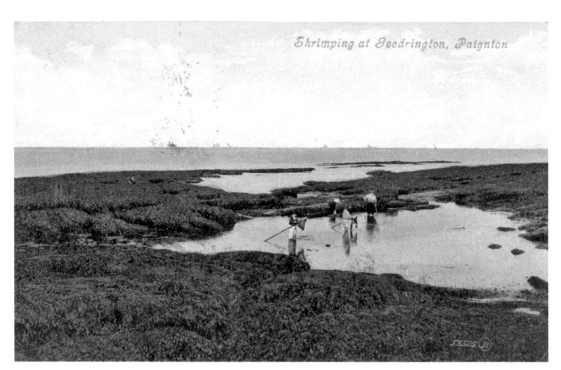

Shrimping at Goodrington
Shrimping at Goodrington
is seen in the early part of
the twentieth century. Today
the Seashore Centre not only
teaches through its displays, but
also takes groups combing the
shoreline and its rock pools at
low tide to discover their secrets.

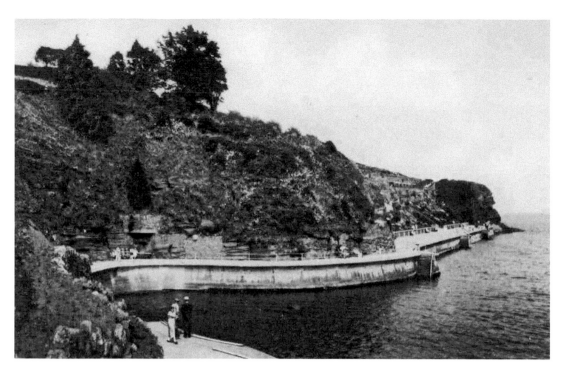

South West Coastal Path

The Promenade around the base of Roundham Head and on to the cliff walk is now part of the South West Coastal Path, which runs from Minehead in Somerset around the tip of Cornwall and to Poole in Dorset.

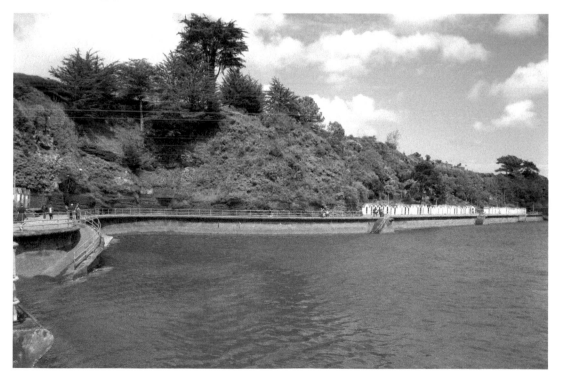

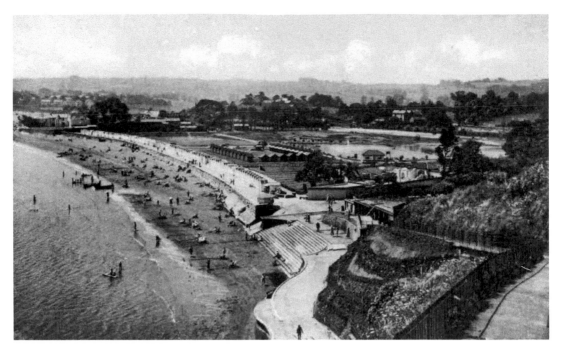

At the Beach
A well-populated beach of yesteryear or today would find refreshment in the café, which is built in a Spanish style.

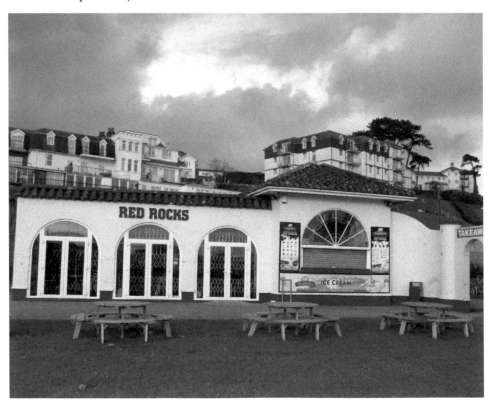

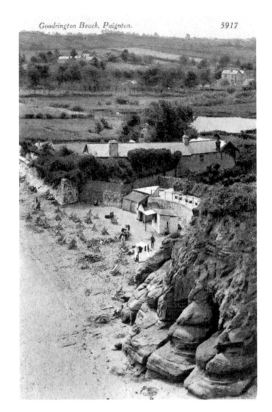

Goodrington Beach, Paignton. 5917

Growth of Goodrington
Little of a resort existed at Goodrington until
the development of the Promenade, park and
cliff walk between 1929 and 1934.

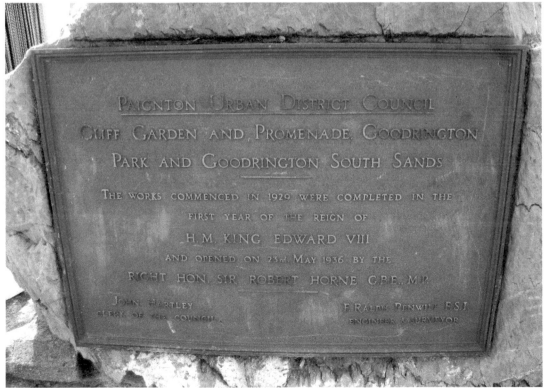

PAIGNTON URBAN DISTRICT COUNCIL

CLIFF GARDEN AND PROMENADE, GOODRINGTON

PARK AND GOODRINGTON SOUTH SANDS

THE WORKS COMMENCED IN 1929 WERE COMPLETED IN THE

FIRST YEAR OF THE REIGN OF

H.M. KING EDWARD VIII

AND OPENED ON 23rd MAY 1936 BY THE

RIGHT HON. SIR ROBERT HORNE G.B.E., M.P.

JOHN HARTLEY F. RALPH PENWILL F.S.I.
CLERK OF THE COUNCIL. ENGINEER & SURVEYOR

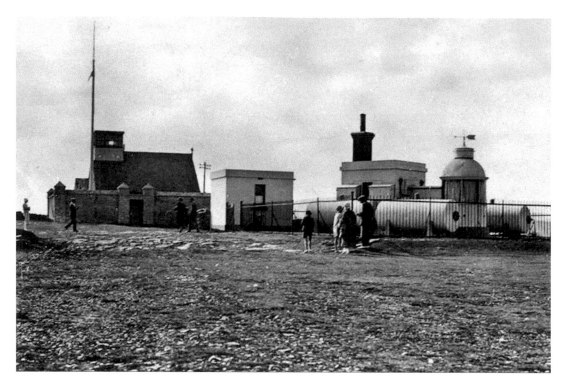

Lighthouse

The lighthouse on Berry Head has three claims to be in the record books. It is the shortest in the country at only 16 feet high; it is also the highest, as it sits atop a headland at 207 feet above sea level; and furthermore the deepest. The mechanism was once turned by a weight which plunged 147 feet down a shaft. It still sends out its signature 5,256,000 double flashes each year.

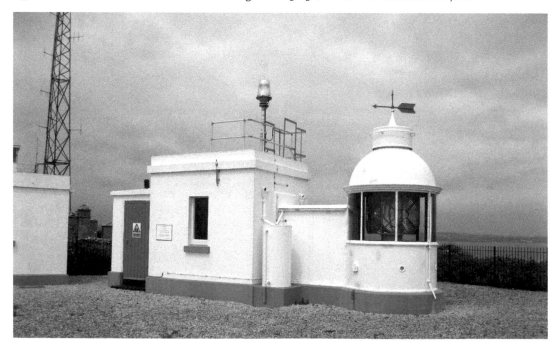

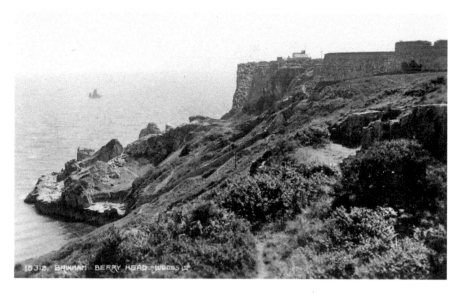

Berry Head

Quarrying at Berry Head continued for centuries, leaving a sizable hole in the 400-million-year-old rocks that form this headland.

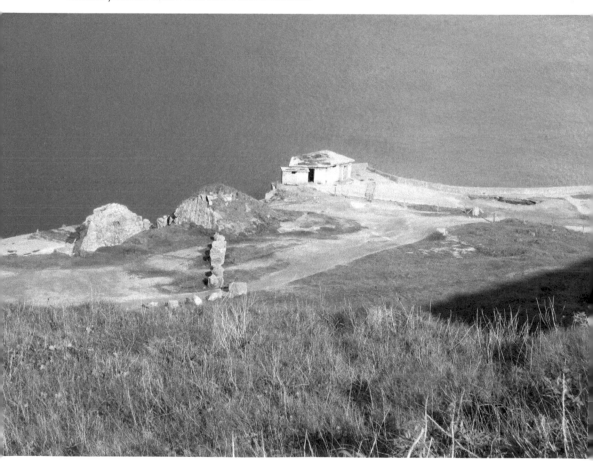

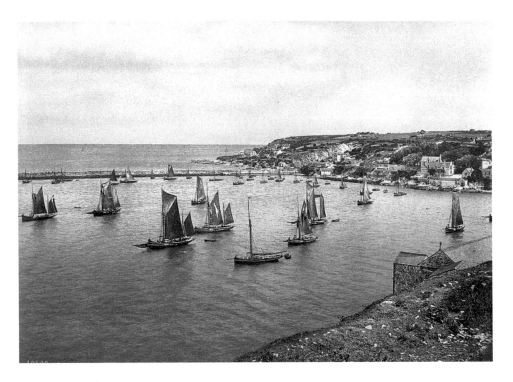

Brixham Trawlers

Brixham was the birthplace of the traditional fishing boat known as the Brixham Trawler. At their peak some 300 vessels sailed out of Brixham, which inspired artists and songwriters – 'Red Sails in the Sunset' was written in 1935 about a trawler named *Torbay Lass* – and made Brixham the leading fishing port in the land. In use up to the Second World War, the four examples seen in Brixham harbour today are used for training purposes.

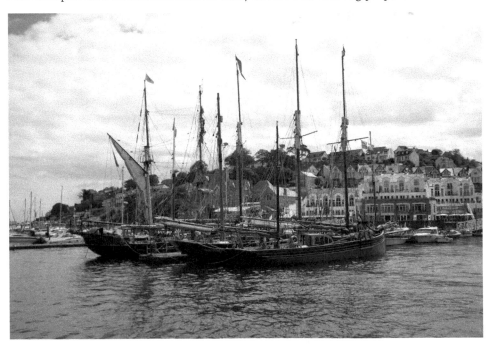

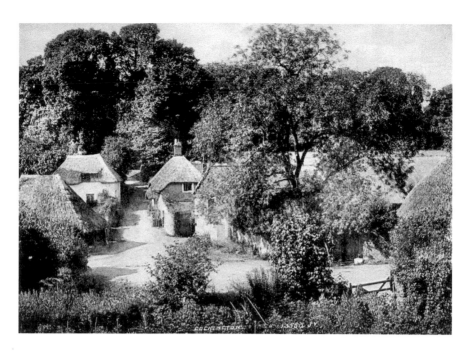

Cockington
That Cockington has changed little over the years is its charm.

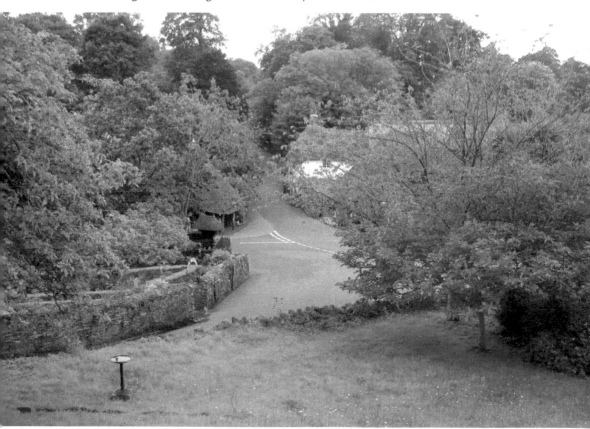

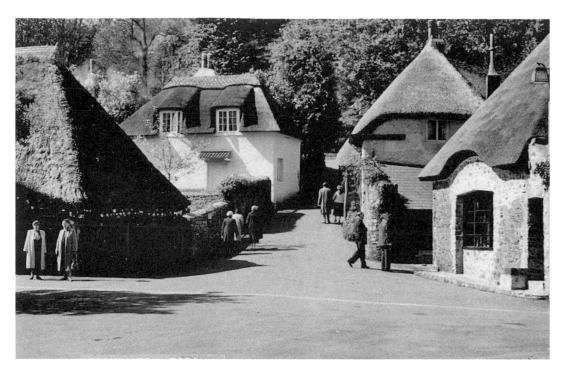

Horsepower at Cockington
Cockington was reached by horsepower for centuries. Today the horse and trap still brings visitors to this charming village.

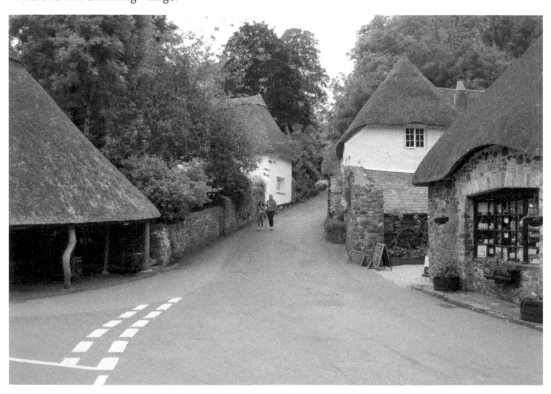

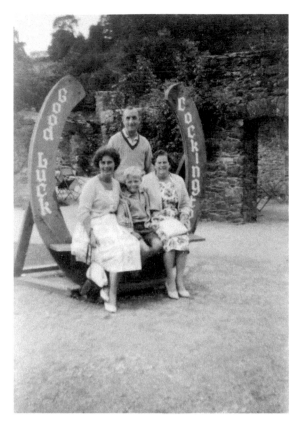

Cockington Manor
The entrance to Cockington Manor was
once marked by an oversized 'good luck'
message. Smaller versions are still sold
at the Old Forge. Today the old wall has
succumbed to the ivy.

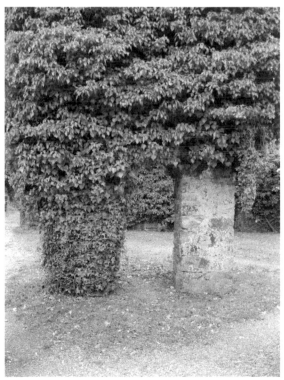

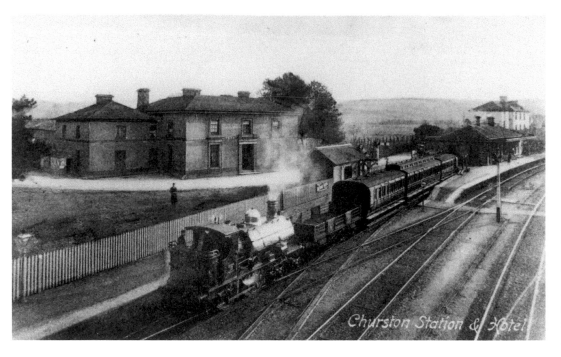

Churston Station

Churston Station and hotel around the end of the nineteenth century. This is the White Horse Hotel. The station remains largely unchanged, owing to the line never closing.

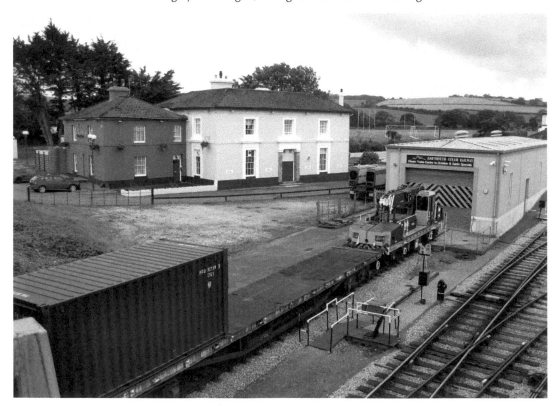

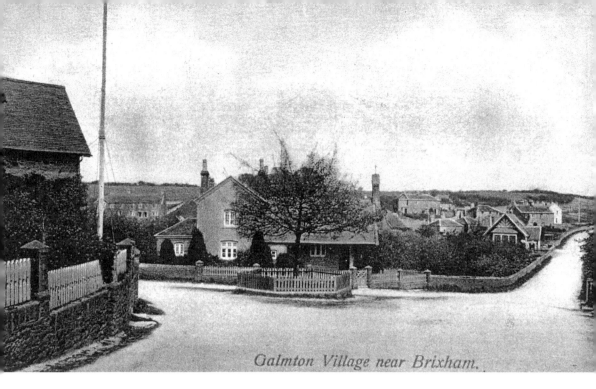

Galmton Village near Brixham.

Galmpton

This image of Galmpton village is thought to date from 1907. Note the sapling in the old photograph is the same as the tree that dominates the modern view. The same is also true of the background, virtually devoid of trees in the early twentieth century, yet plenty to be seen today. This seems to be contrary to everything we hear about our countryside, but is quite logical considering that wood was used for building and fuel for all but the last 200 years.

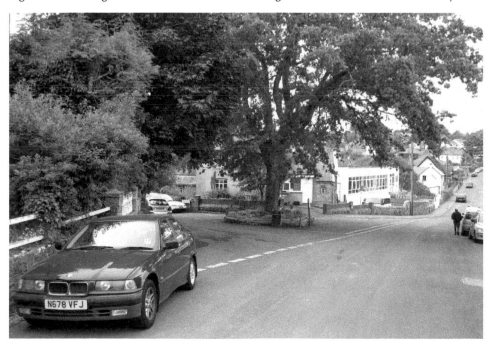

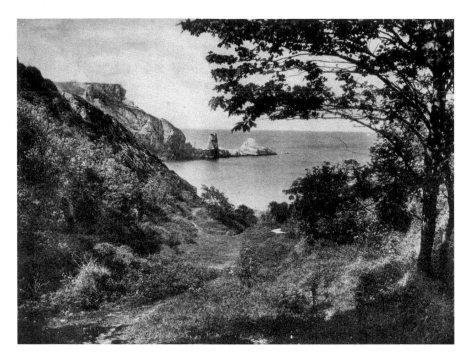

Anstey's Cove

Anstey's Cove has seen little erosion over the last century, although, as with the previous image, vegetation has increased noticeably.

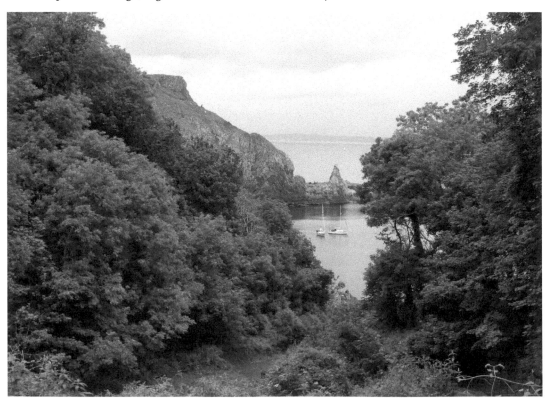